LEGENDARY LOC

OF

HAMTRAMCK

MICHIGAN

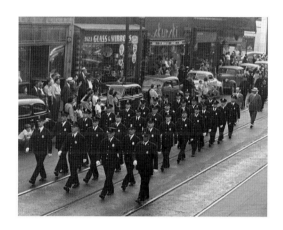

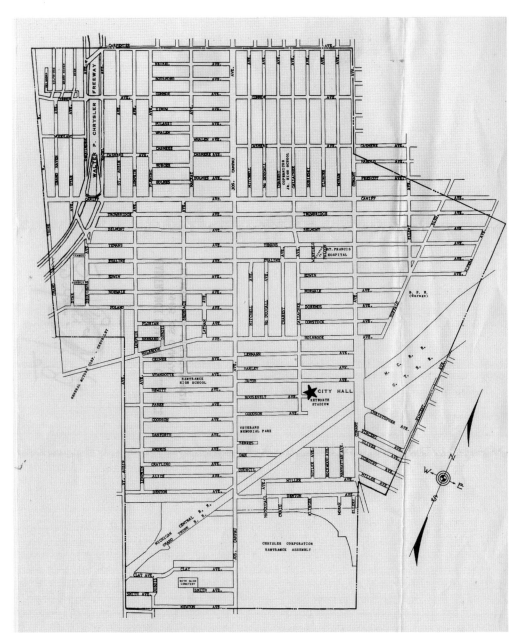

Page 1: The Spirit of Hamtramck

So much of Hamtramck is represented in this picture of the Memorial Day Parade in 1945. Police march down Jos. Campau, the city's main street, on the streetcar tracks in front of the shops that gave the city so much vitality. Hamtramckans have always loved a parade. And above them is a billboard for Schmidt's beer. Strong drink played a long role in the city's history.

Page 2: Map of Hamtramck

At 2.1 square miles, Hamtramck is packed with homes, businesses, and people. It went from being nearly vacant to highly developed in the space of 10 years.

LEGENDARY LOCALS
OF

HAMTRAMCK
MICHIGAN

GREG KOWALSKI

LEGENDARY
LOCALS

Published by Legendary Locals, an imprint of Arcadia Publishing
Charleston, South Carolina

Printed in the United States of America

Library of Congress Control Number: 2011945804

For all general information, please contact Arcadia Publishing:
Telephone 843-853-2070
Fax 843-853-0044
E-mail sales@arcadiapublishing.com
For customer service and orders:
Toll-Free 1-888-313-2665

Visit us on the Internet at www.arcadiapublishing.com

Dedication
To my most loyal supporter, my mother, Martha Violet Kowalski.

On the Cover: From left to right:
(TOP ROW) Lee Barecki, Miss Dodge Days; see page 97, Rev. Joseph Jordan, pastor, Corinthian Baptist Church; see page 84, Walter Kanar, mayor; see page 79, Gail Kobe, actress; see page 44, Msgr. Peter P. Walkowiak, St. Florian Parish; see page 84.
(MIDDLE ROW) Ordine Toliver, Hamtramck village councilman; see page 11, Mary Zuk, councilwoman, activist; see page 78, Joseph Lewandowski, mayor; see page 18, Walter Gajewski, city clerk; see page 19, Karen Majewski, first woman mayor; see page 32.
(BOTTOM ROW) Yvonne Myrick, library board member; see page 99, Peter Jezewski, first mayor; see page 12, Stephen Skrzycki, mayor; see page 20; Woodrow W. Woody, auto dealer; see page 64, Albert Zak, mayor; see page 21. (All cover images courtesy of the Hamtramck Historical Commission.)

CONTENTS

ACKNOWLEDGMENTS

All the photographs in this book were drawn from the archives of the Hamtramck Historical Commission, unless otherwise noted.

INTRODUCTION

Every life is important, and everyone who lives leaves an impression on the world; but, the notice, or notoriety, each attains can vary greatly. Some of us come and go with barely a mention; volumes are written about others. And when you are examining the tapestry of a town whose history spans centuries, the variety of people is staggering. Yet in all that multitude, some people stand out—for better and for worse.

In that respect Hamtramck, Michigan, is no different from any other town. But take a closer look and you will find an amazing assortment of characters. It has been that way from the beginning. Hamtramck derived its name from Jean Francois Hamtramck, a French-Canadian born in Quebec in 1756. Hamtramck came to the young United States to fight with the Americans against the British in the Revolutionary War. Along the way, he changed his name to John Francis, and in 1794 came to the Western Frontier, which encompassed the Michigan-Ohio area, to root out the British who had stayed in Michigan after the Revolutionary War.

Hamtramck was successful, and in recognition of his accomplishments, the area bordering Detroit was named Hamtramck Township. It originally stretched from the Detroit River to Base Line (now Eight Mile Road) and from Woodward Avenue through the Grosse Pointes.

Through the 19th century, Hamtramck shrank as it was annexed piece by piece by the growing city of Detroit. It gradually disappeared with little notice. For the most part, Hamtramck Township was a farming community in this era. Its most densely populated area was along the shore of the Detroit River where factories and breweries clustered. But just a short distance north of the downtown area, Hamtramck became a landscape of fields, orchards, and forests.

Few names and even fewer images from those early days have survived to today, and many of those that do are still sadly anonymous. We know that Louis Chapoton owned a house, a cow, and two horses, while Pierre Rivarre did not fare as well, with only one cow and one horse. They were neighbors, or at least fellow residents, in Hamtramck Township in 1802. We know that from the census of the area, but the listing of residents is spotty and sporadic. That even applies to township officials. There is only a partial list of the township supervisors that starts with Charles Moran in 1827. He was followed by Peter Van Every in 1833 and a host of others including W.B. Hunt, John M. Mack, and James Holihan.

Little is known about any of them, and only Moran's name is commonly known today thanks to the street named after him—although it is doubtful if more than one resident on the street knows his role in Hamtramck's history. There are tantalizing links to the other folks who inhabited the area as well. We have a drawing of Albert Breitmeyer's farm, but exactly where it was located and who he was remain mysteries.

From 1901 on, more is known about the town and its leading figures. That was the year a group of residents in the north-central area of the township carved out the Village of Hamtramck, a 2.1-square-mile community that clustered along Jos. Campau Avenue, which even then was the city's main street. Incidentally—Joseph Campau, the man, not the street—was a prominent early-19th-century Detroit businessman who was the largest landowner in the area.

With village status came village officials—and official records. The faces of Hamtramck began to emerge. In the first village election, John Berres received 120 votes for trustee, followed by Anson Harris (116 votes), Ernest Oehmko (110 votes), Henry Krause (110 votes), and George Mertz (a mere 58 votes).

The Berres name lives on with Berres Street. But all of these early officials are largely forgotten and we know nearly nothing about them. But there are village records showing how they voted on the issues of the day, such as installing a water system in the village.

And the names tell us something by their very nature. Through the 19th century and into the first decade of the 20th, it was Germans who dominated Hamtramck. That would change dramatically after 1910. In that year, John and Horace Dodge came to Hamtramck looking for a place to locate their new auto factory.

They began construction in June 1910 and by November were producing parts for Henry Ford. But they had much bigger ideas. They wanted to build their own cars and as they ramped up production, they put out a call for workers. The call was answered in an astonishing way. Thousands of immigrants, almost all Polish, flooded into Hamtramck. In 1910, 3,500 people lived in the 2.1-square-mile Village of Hamtramck. By 1920, the population swelled to 48,000—and that would grow to 56,000 by 1930.

In a remarkably short time, Hamtramck became a major industrial town. By 1922, the village had incorporated as a city, and the smokestacks of more than 20 factories were rising up into the increasingly dirty sky.

The stage was set for a huge cast of characters. Through the 19th century, Hamtramck was mainly inhabited by French, and later, German farmers and merchants. There also was a small African American population, but all of them were overwhelmed by the Polish immigrants who poured into town after the Dodges opened their factory. The old German names like Geimer, Berres, and Haas were giving way to new ones like Majewski, Jezewski, and the more challenging Dziengielewski.

Hamtramck was becoming a city filled with all manner of characters, good and bad. This 2.1-square-mile enclave that eventually was totally surrounded by Detroit produced an extraordinary assortment of notable figures. Hamtramckans made major contributions to the fields of education, science, entertainment, sports, labor, and—alas—crime. Some achieved international recognition.

Hamtramck had become one of the largest cities in Michigan by 1930, and its mainly Polish population embraced democracy with a passion. Most locals were attracted to the Democratic Party, which had close ties to the labor unions and favored social programs that were desperately needed in Hamtramck, especially during the Great Depression years.

It was not unusual for Hamtramck to post a 90 percent voter turnout at an election, and with the vast majority voting Democratic, Hamtramck became a political powerhouse, drawing presidents and national politicians for campaign swings and visits to town. They, however, are diversions in the story of Hamtramck. The real story is with the everyday people who built the city and made it what it is.

Over the centuries, hundreds of thousands of people have lived in Hamtramck, and picking out a select few to highlight is difficult. But some do stand out for a variety of reasons. Let's get to know them.

CHAPTER ONE

The Leaders

Politics in Hamtramck has never been a spectator sport. From its earliest days as a city, Hamtramck's political scene was noted for its rambunctious nature. More than one city official ended up in prison, usually for violating some Prohibition-generated law. It wasn't until the 1940s that the political scene calmed down—somewhat.

From the early wild years and down the decades to the present, an amazing assortment of men and women led the city through times of prosperity and poverty. Although the range of personalities was wide, they all left a mark on the city, and for the most part, sought to make it a better place.

Early Leaders
Nameless today, these were among the early leaders of Hamtramck.

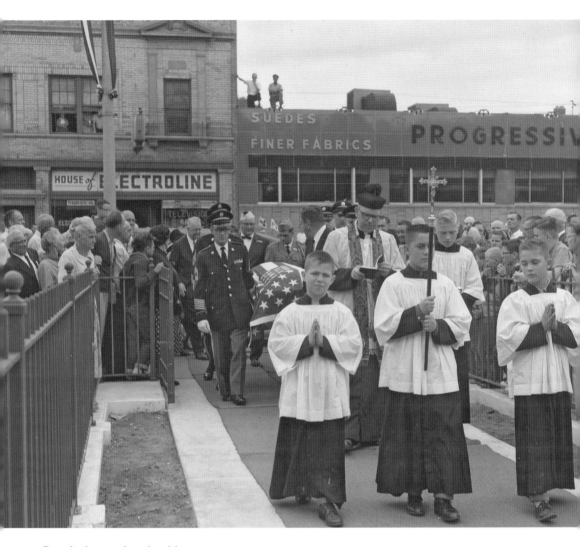

Revolutionary Leadership

Col. John Francis Hamtramck is buried at Veterans Memorial Park in Hamtramck. But ironically, even though he is so closely associated with the town that bears his name, there are no pictures of him. When he died in 1803, all of his possessions were placed in storage, and they were all lost in the great fire that destroyed Detroit in 1805. But we do know a lot about his life. Jean Francois Hamtramck was born on August 16, 1756, in Quebec, Canada. At the time Quebec was occupied by the British, which instilled in Hamtramck a deep hatred of them. He came to America to fight with the Americans in the Revolution. He distinguished himself in the service and was regularly promoted. Following the Revolutionary War, Colonel Hamtramck remained with the new US Army, and was sent by Pres. George Washington to this area in 1794 to remove the British, who had remained after the Revolution, harassing the Americans. The troops of Colonel Hamtramck—who had legally changed his name to John Francis Hamtramck by this point—accepted the surrender of the fort at Detroit from the British in July 1796. Colonel Hamtramck settled on a farm alongside the Detroit River in what came to be Hamtramck Township, which was named in his honor when it was first formed in 1798. He was buried by St. Anne's Church and later was moved to Mt. Elliott Cemetery in Detroit, where he reposed until 1962 when he was laid to rest—again—at a special ceremony held at the park.

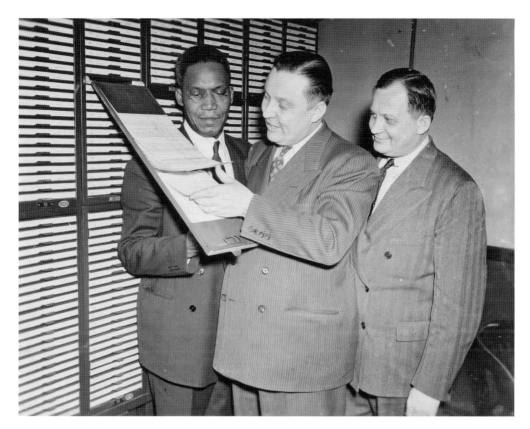

Many Achievements (ABOVE)
Ordine Toliver had a long and varied career in Hamtramck. An African American in a predominantly white, overwhelmingly Polish immigrant community, he nevertheless was elected to the village council in 1920. A man of many talents, he also wrote music and operated a music studio on Jos. Campau, where the majority of his students were white. Those who knew him loved him, black and white. He's pictured with Mayor Albert Zak (center) and August Lang.

Clean Service
Walter Merique's service to Hamtramck is distinctive for two reasons. He was the city's first treasurer, serving 10 years in that post beginning in 1922. He also served on the city council for one term from 1932 to 1934. And his years in office were remarkable in that there was not a hint of scandal associated with him through Hamtramck's wildest days.

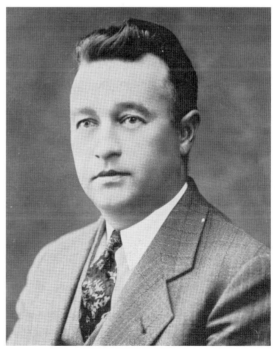

The First Mayor

Peter C. Jezewski came to Hamtramck from Buffalo, New York, and opened a pharmacy on Jos. Campau at Belmont Street. That quickly became his center of power, serving as a headquarters for a political machine he would develop and nurture through Hamtramck's earliest days as a city. In 1922, when Hamtramck incorporated as a city, he was elected as its first mayor. Hamtramck at that time was known as a wild town where Prohibition was an opportunity and vice was rife. Jezewski was not immune to the lure of easy money to be made on the other side of the law, as he was soon implicated in a bootlegging scheme. A stint in prison, however, was only a blip on his political radar screen. He served two terms as mayor from 1922 to 1926 and was elected again in 1932. In between, he played a behind-the-scenes role manipulating—or trying to—the political landscape, including who would run to succeed him. But by 1934, the people of Hamtramck were fed up with the seemingly endless bad headlines on the corrupt state of Hamtramck, and Jezewski lost his bid for re-election. He faded from the political scene and died in 1960, suffering a heart attack on Jos. Campau, just a block or so from his pharmacy. That building still stands.

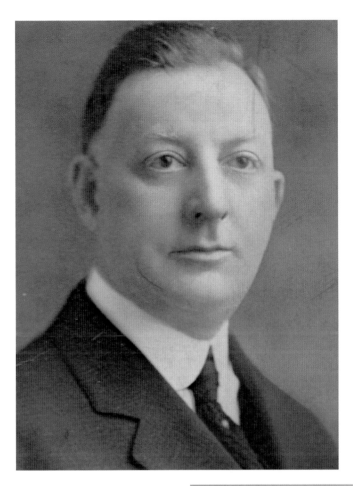

The Chief, and More

Fred C. Dibble had one of the most colorful and convoluted public careers of anyone in Hamtramck's history. A police officer in Detroit, he took a leave of absence to accept an offer to become Hamtramck's police chief in 1919, when village president George Haas fired then-chief Barney Whalen. But Dibble and Haas soon had a falling out, and Dibble was fired. He retaliated by forming the Victory Party and winning a seat on the village council. In 1922, he lost a bid to become mayor of the newly chartered city of Hamtramck, but he did win a seat on the city council in 1926 and 1928. He lost in the 1930 election and was unemployed for six years. When he died in 1937, his total assets amounted to $5.35.

Groundbreaker

James L. Henderson occupies a remarkable place in Hamtramck's history. An African American, he was elected to Hamtramck's first city council in 1922, when the city was overwhelmingly white and Polish. African Americans formed a major voting block in the city and played a pivotal role in deciding the vote in favor of city status.

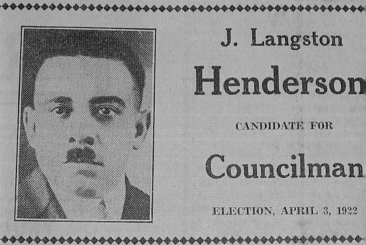

J. Langston

Henderson

CANDIDATE FOR

Councilman

ELECTION, APRIL 3, 1922

Act Two

Stephen Majewski had the impossible task of succeeding Peter Jezewski as mayor in 1926. A former supporter of Jezewski, the two parted ways for reasons that aren't clear today. But when Majewski took office, he was faced with trying to work with a common council that still was strongly aligned with Jezewski. Adding to the difficulty was that Majewski didn't even want to be mayor. He ran for office because Jezewski had been convicted for a Prohibition violation and was facing a sentence in federal prison. As the appeal process went on, Jezewski insisted on running for a third term. This alarmed Majewski, as well as some other like-minded persons in town, who feared if Jezewski won a third term and his appeal failed, he would be forced to resign. In that case, common council president Fred Dibble would automatically be appointed mayor. At the time, Hamtramck was divided politically, with the new Poles forming the North Side political alliance while the old residents, mainly Germans, lived on the South Side of town. Dibble was from the South Side. And he had developed a somewhat unsavory reputation. The North Siders tried to solicit other candidates to run for mayor, but when that failed, Majewski stepped in. He attempted to implement some civic improvements, such as making operational the municipal hospital the city had built, but didn't have money to equip. He also finally got the plan to build the Jos. Campau viaduct moving. But he could make almost no headway in cleaning up corruption that was rampant at the time, especially regarding Prohibition, gambling, and prostitution. Majewski ran for re-election in 1928, but Jezewski's long reach extended even from Leavenworth Prison. He and his supporters engineered a plan for political newcomer Dr. Rudolph Tenerowicz to run for mayor. His story is told in chapter 6. At any rate, Majewski reflected years later that he had made a greater impact as a member of the school board in the 1920s. He had participated in one of the best decisions that any Hamtramck official ever made—the hiring of Maurice Keyworth as school superintendent (see chapter 2). Majewski served in other offices as well including justice of the peace during a long public life.

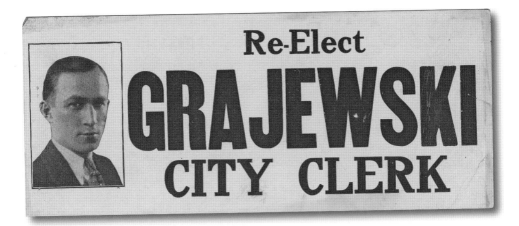

Re-Elect

GRAJEWSKI
CITY CLERK

Shooting Star

Like a shooting star, Michael Grajewski's political career took off swiftly, burned brightly for a short time, and faded fast. Grajewski was deputy township supervisor by age 18. He quickly rose through a series of other posts including serving as state representative. Then, for reasons that are not clear, the public turned against him and his career was over, as he failed to even be nominated for the city council in 1936. Within a few months he was dead, officially of pneumonia, but more likely of a broken heart.

Key Figure

A man of many talents, Arthur Rooks seemed to be everywhere in Hamtramck's early city days. He served as a municipal judge from 1930 to 1942 and founded the Boys Club of Hamtramck. Interested in sports, he helped establish the Hamtramck Recreation Department and coached the Wolverines, Hamtramck's semi-pro baseball team. He died in 1972 at age 78.

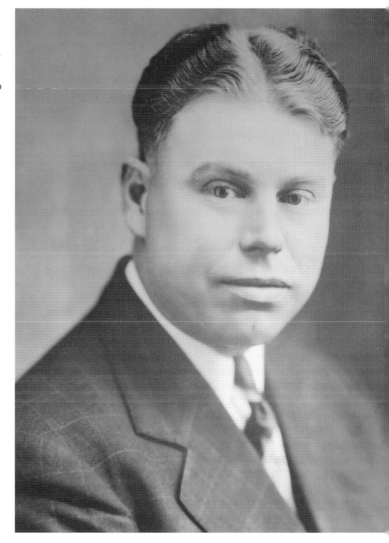

Across the Years
Never before—or since—has there been a meeting of officials like this one, dating from the first City Festival in 1981. Pictured are from left to right (front row) Mayor Raymond Wojtowicz, Mayor William V. Kozerski, Mayor Joseph Lewandowski, Mayor Joseph Grzecki Sr., and Margaret Tenerowicz, wife of Mayor Rudolph Tenerowicz; (back row) Councilman Paul Odrobina, Councilman Eugene Pluto, Councilman Jerry J. Wandolowski, Mayor Robert Kozaren, Councilwoman Helen Justewicz, Treasurer Joseph Grzecki Jr., Public Safety Director Henry Jablynski, Councilman Frank Rembisz, and City Clerk Robert Zwolak.

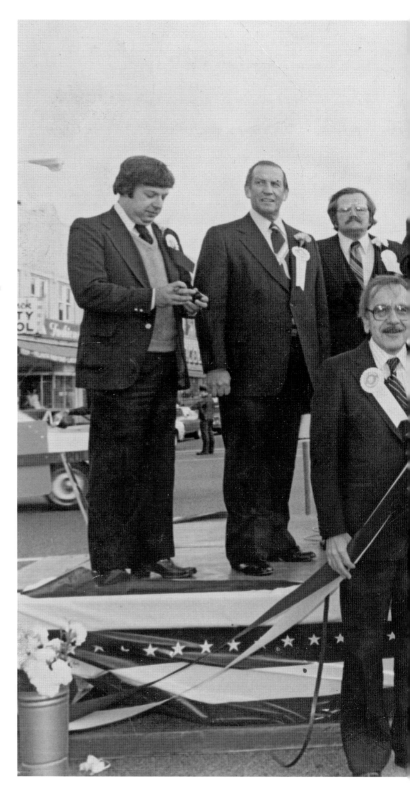

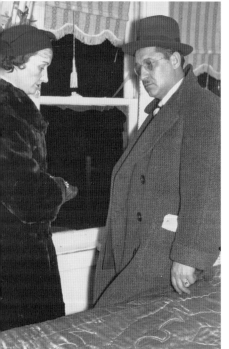

Christmas Maker (ABOVE)
Joseph Mitchell's career with Hamtramck spanned its village and early city days. Mitchell was elected village clerk, and won the post as city clerk in 1922. Prior to serving as clerk, Mitchell was in charge of the village's Welfare Department for seven years. But maybe his greatest accomplishment was in starting the municipal Christmas tree program. From 1922 to 1928, the program provided toys to 7,000 to 8,000 kids at Christmas. Here Mitchell is shown with Mayor Stephen Skrzycki (left) and Stephen Malicki (right).

Mayor Lewandowski
Joseph Lewandowski was the fourth person to serve as mayor of Hamtramck. He defeated Peter Jezewski, who had returned to office in the early 1930s after being out of office for several years. Lewandowski served one rocky term from 1934 to 1936. It was a tumultuous time politically in Hamtramck, with the Lewandowski campaign marked by a bomb being exploded next to his house in 1936. (In photo, he and his wife are examining the damage outside their bedroom window.) No one was hurt, and Lewandowski lost the election to the venerable Dr. Rudolph Tenerowicz. But it wasn't the end of Lewandowski, who went on to serve as a municipal judge for 20 years.

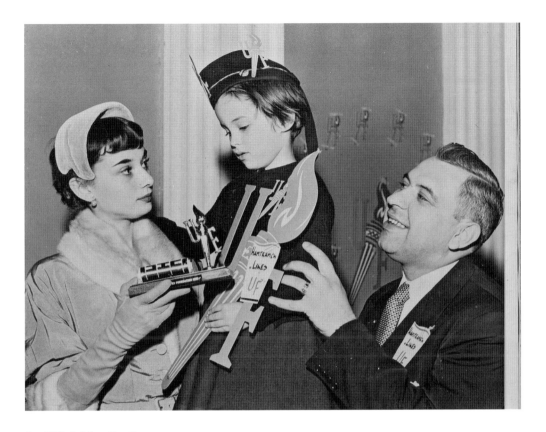

An Official for the Ages

There was a time when it seemed like Walter Gajewski was always Hamtramck's city clerk and always would be. Gajewski was first elected clerk in 1950 and won re-election every two years for nearly 30 years. He was one of the longest-serving officials in America. That kind of success isn't accidental. Gajewski may have been the greatest politician in Hamtramck's history—and the word politician is used here in the best sense. Through his long career, Gajewski was a consummate gentleman. He adored his position and lived his role as a city official to the fullest, representing the city at innumerable events, even meeting with actress Audrey Hepburn (in photo) to promote the city's United Foundation drive. He also knew how to play the political game. He was known to go to a restaurant and have himself paged so people would know that he was the clerk and he was present. He also used gamesmanship to benefit Hamtramck. His one-time deputy clerk Robert Kozaren—who would later become mayor—recounted how at one countywide election Gajewski held off on reporting the city's results to the county clerk until all other communities had been counted. The Hamtramck numbers appeared to tip the tally in favor of one candidate, making it appear as if the whole election had turned on the results from Hamtramck, giving the city a greater importance. Gajewski carefully built his base of support, belonging to numerous organizations. A World War II veteran, he was a member of the Polish Legion of American Veterans, and a life member of the Disabled American Veterans and Amvets Post 14. He also was a member of the Knights of Columbus, the Polish Roman Catholic Union, and the Hamtramck Goodfellows. While it seemed that Gajewski would be clerk for life, Hamtramck's political climate underwent a major change in 1979 with the closing of the Dodge Main factory. Faced with a crisis situation, the residents were looking for new, bold leadership. Robert Kozaren offered that, but Gajewski chose to align himself with the incumbent administration. It was a politically fatal error. Gajewski was voted out of office. But even in the face of a stunning defeat, he remained a gentleman, accepting his loss with the great dignity that was a hallmark of his life. He died in 2000.

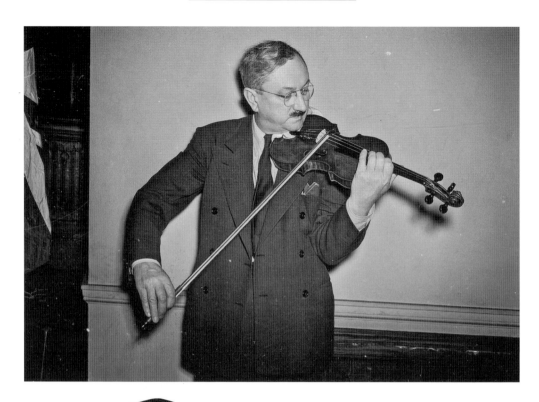

Doctor/Mayor (ABOVE)
After decades of unending scandals, Hamtramckans finally had had enough with corrupt politicians and elected Dr. Stephen Skrzycki as mayor. His years in office, from 1942 to 1952, were marked by relatively calm government and a lack of scandals. He also played the violin. Dr. Skrzycki died of cancer in 1956.

A Name to Remember
For a time, it seemed that John Anger's name was everywhere. He was elected treasurer in 1932, and his name appears on the Hamtramck currency that was issued in 1933 and 1934. Beginning in 1921, Anger held a variety of positions with the city, including being sanitary inspector, Department of Public Works (DPW) clerk, and water department clerk. He was also a member of the city council twice.

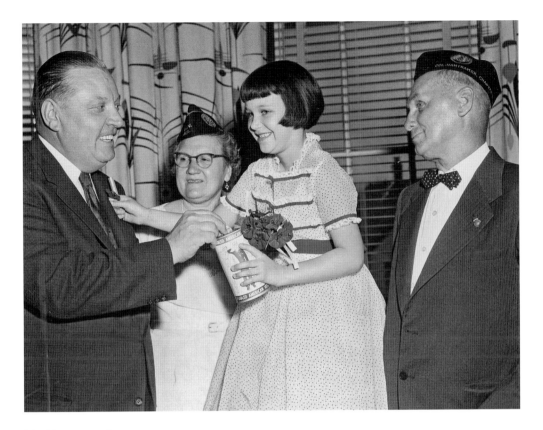

Mr. Hamtramck

If Hamtramck ever had a Golden Age, it was the 1950s. And if anyone ever was most associated with it, it was Albert Zak. Even today the city's old timers think of Al Zak as Hamtramck's greatest mayor. He was a tireless supporter of Hamtramck and was almost fanatical in his obsession to keep the city clean. And indeed, during his terms in office, the city won awards as one of the cleanest in the nation. Zak was born in Hamtramck and attended St. Florian School in the city. He dropped out of school to work at the Dodge Main auto plant, and began dabbling in politics. In 1940, he was elected city clerk and quickly realized that he fit comfortably into the political scene. Zak also served as a state legislator for a while, but it was in Hamtramck that he achieved his most satisfying success. Zak was elected mayor in 1952 and seemed to make the city an extension of his office. He dominated the town, leading efforts to improve the city, including paving all the alleys with asphalt. He also played the political game expertly, dominating the council, lording over the various departments, and working with the public. The scene depicted in the photo is typical. It dates from the mid-1950s and shows Mayor Zak (at left) contributing to the Disabled American Veterans Poppy sale. With him is Josephine Skopowska of the DAV Ladies Auxiliary; little Linda Tokarski pinning a poppy on the mayor; and poppy drive chairman John Ochemski. Countless events like these helped endear Zak to the hearts of Hamtramckans. But it wasn't all for show. Zak genuinely loved Hamtramck, and the people seemed to appreciate it, electing him to a then unprecedented six straight two-year terms. He resigned from office in 1963 to take a position with the Wayne County Civil Service Commission. He later served on the Wayne County Board of Commissioners, but couldn't stay away from Hamtramck. He returned to local political life and was elected mayor again in 1973. In February 1975, Zak attended a stormy session of the city council. He and his aide Walter Bielski stopped at the Clock Restaurant. Exiting their car, Zak suddenly said he felt faint. He then collapsed in Bielski's arms, suffering a massive heart attack. He died on the way to the hospital. He was 65.

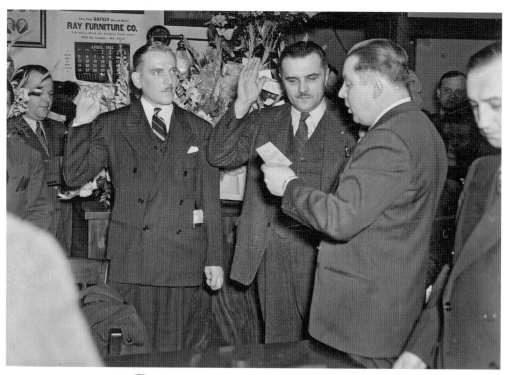

Top Vote Getter (ABOVE)
Walter Bednarski (left) takes the oath of office as city treasurer from clerk Albert Zak in 1942. In all, Bednarski served 14 years as treasurer beginning in 1940. That year, he garnered more votes than anyone else running for office. At center is the popular Judge Nicholas Gronkowski.

Patriotic
John Ptaskiewicz was the first—and only—city official to resign from his job to join the Army at the start of World War II. He was elected to a second two-year term as city constable in April 1942, and resigned the following November. Even in the Army he stayed involved in politics, endorsing candidate Peter Szymczak for mayor in 1946.

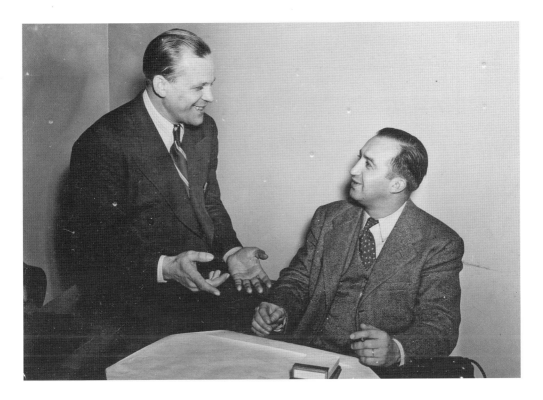

Longtime Service

Two veteran Hamtramck figures confer in 1942—council president Walter Serement (seated) and John Pitlosh. Pitlosh was best known for his community activities, but did serve on the common council from 1974 to 1976. Pitlosh's involvement in city government actually spanned decades as he was involved with the city in numerous capacities.

Legal Concerns

Between the public school system and city government, Michael Mozola spent decades taking care of the legal business of Hamtramck. After serving five years as the school board attorney, he was appointed assistant city attorney in 1947. He also served a stint on the common council in 1972. He's at right with candidate for governor Harry Kelly (center) and Walter Danielson.

23

The Mayor, Briefly (ABOVE)

Even the most ardent Hamtramck historian is likely to overlook that Anthony Tenerowicz served as mayor for a few months in early 1942. As council president he became mayor on the resignation of Mayor Walter Kanar (at right in photo). That ignited a political firestorm and legal challenges, but Tenerowicz finished Kanar's term. He was the brother of the popular mayor Dr. Rudolph Tenerowicz.

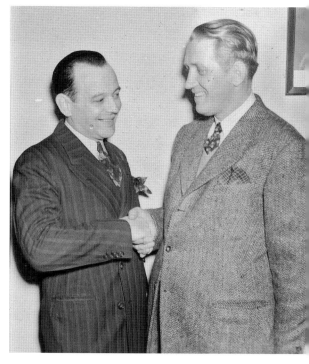

Fearless

One of the feistiest politicians in Hamtramck's history, John Wojtylo would take on anyone. He even sued the local newspaper for refusing to run one of his political ads. Never afraid of controversy, he advocated opening soup kitchens in Hamtramck in 1952 to aid laid-off auto plant workers. He served on the council almost continuously from 1942 to 1956. He died in 2003 at age 92.

An Immigrant's Story

Thaddeus Machrowicz was born on August 21, 1899, in Gostyn, Poland. At age three, he was brought by his family to America and eventually came to Hamtramck. In 1934, he was named as Hamtramck's city attorney and served as a municipal judge. Eventually, he was appointed federal district court judge. He died in 1970. In the photo, Machrowicz (left) is with fellow municipal judge Arthur Rooks.

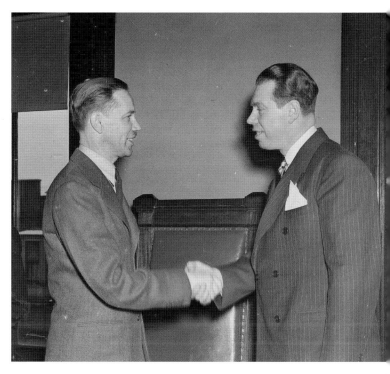

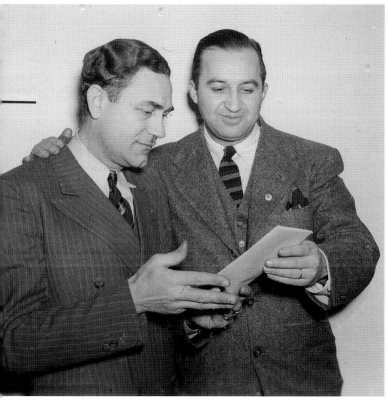

Mr. Politician

Walter Serement (right) didn't distinguish himself greatly as a councilman, but in many ways he epitomized *the* Hamtramck politician. He held a host of positions including the city's welfare department director, and led a bond drive in World War II. (Here he's selling bonds to Cornelius Moll of the UAW.) He was appointed assistant city controller in 1936 and served on the council from 1942 to 1952. He also owned a bar.

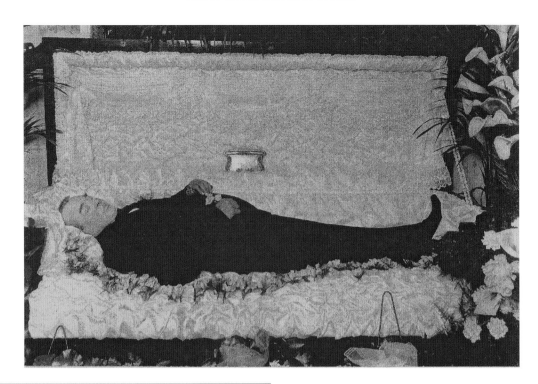

At Rest

In the early part of the 20th century, there was a curious custom of photographing the deceased as they rested in their caskets, usually in the living room of the deceased's home. Such is the case here with Louis Merique, a member of one of Hamtramck's most prominent early families. Merique was born in Mulhausen, France, in 1865 and moved to the Detroit area at age 18. He served as justice of the peace in Hamtramck Township from 1907 to 1919 and Hamtramck Village treasurer from 1919 until his death in 1921 at age 54. The picture was taken in Merique's house on Clay Street. The plaque in the casket reads "At rest."

Andrew Templeton

Andrew A. Templeton was the son of Andrew Templeton, a member of the city's first council in 1922. But Andrew A. carved out an impressive record of achievement on his own. He was particularly active in veterans' affairs, having served as the American Legion field service officer at the veterans' hospital in Dearborn, Michigan. He also served as Legion state commander and in a variety of other Legion positions.

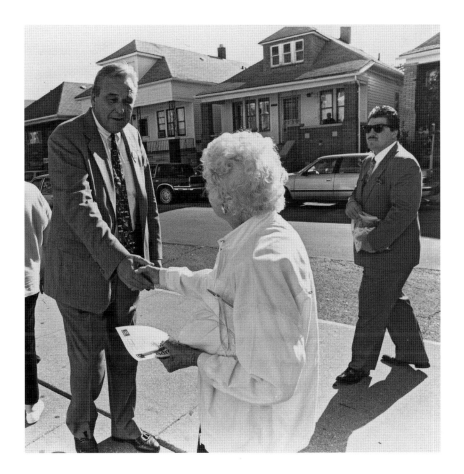

Big Bob

Robert Kozaren was a big man in many ways. Physically, he stood about six-foot-six. And when he took over as mayor of Hamtramck in 1980, he was faced with the biggest crisis that had ever threatened the city. Shortly after he was elected, the Chrysler Corporation announced that it was going to close the Dodge Main factory. The great plant had provided about one-quarter of the city's tax revenue for decades, and its loss left the city teetering on bankruptcy. Within a year, however, General Motors announced it wanted to build a new factory straddling the Hamtramck-Detroit border. Kozaren worked tirelessly with GM and City of Detroit officials to make the deal a reality. Kozaren made use of his enormous people skills to forge relationships and build trust. Kozaren also had an abundance of enthusiasm, even when the city faced its worst days. But he understood that good intentions aren't enough. To lift the city's spirits and regenerate faith in the town, he began the popular annual City Festival. Kozaren's efforts paid off, not only for the city, but his own political ambitions. He served as mayor for 18 years, far longer than any other mayor. But his interests did not reach beyond the borders of the city. He loved Hamtramck with a passion. A 1952 graduate of St. Ladislaus High School, Kozaren was perhaps the ultimate Hamtramckan. He didn't drive a car, but was content to walk around town, and was easy to spot on the streets. He loved practical jokes, but was never cruel. In his later years in office, he had difficulty coping with the changing nature of the city as new immigrants arrived, and the old ways of doing business with a handshake gave way to the realities of modern city management. After he left office, he virtually dropped out of sight, although he resurfaced a bit just before his death in 2007 at age 73. And whether one loved him or not, no one could deny him his looming place in Hamtramck's history.

27

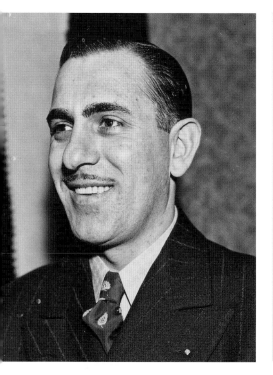

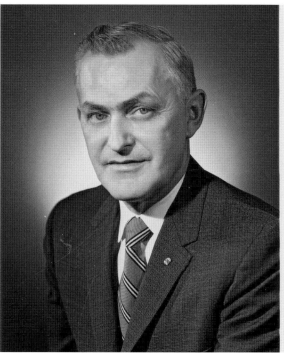

Ever Vigilant (ABOVE LEFT)

Joseph Wisniewski was appointed director of public safety by Mayor Walter Kanar on December 19, 1941—12 days after the attack on Pearl Harbor. He wasted no time in announcing that he would focus the police and fire department on defense, particularly guarding against sabotage. Actually, he had a point. With the big Dodge Main auto plant ready to be turned over to war production, it was a serious target. But it never was attacked and Wisniewski's tenure in his position was equally as uneventful.

Bars and Ballots (LEFT)

In a way, Vasil Vasileff (left) was the prototypical Hamtramck politician. He owned Vasil's Bar and served on the city council in the early 1960s. Over the years, numerous politicians used bars as power bases. He also served as deputy DPW superintendent and was a member of several veterans' organizations. He died in 2001 at age 78. (Courtesy of the *Review*.)

The Gentleman Mayor

He was a gentleman who carried himself with class and dignity. William V, Kozerski (above, right) had a long history of public service, serving as city treasurer in the 1950s. He became mayor by default when, as common council president, he was appointed mayor after Mayor Albert Zak died in 1975. He was re-elected in 1977 but lost two years later to Robert Kozaren. He died in 2003 at age 83.

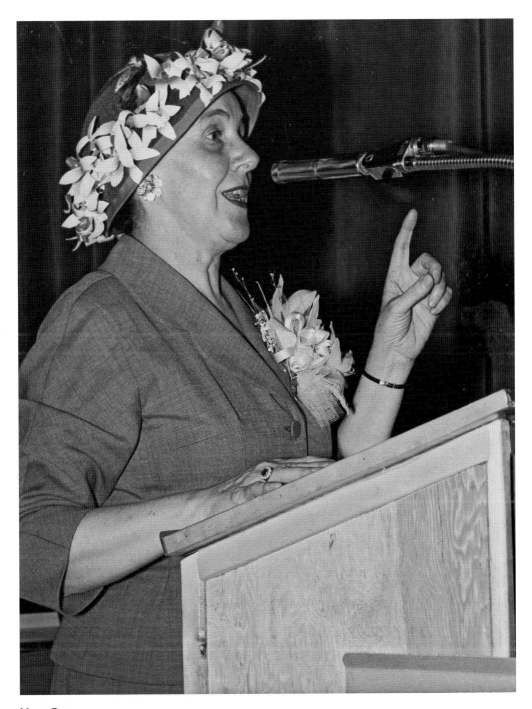

Hats On

Julia Rooks was the second woman ever elected to the city council—in 1950—and she served 20 years in office. But she was the first woman to be city council president. She was known for her colorful hats, a trademark she said she picked up from longtime Detroit councilwoman Mary Beck. Rooks was involved in many civic programs through her long tenure.

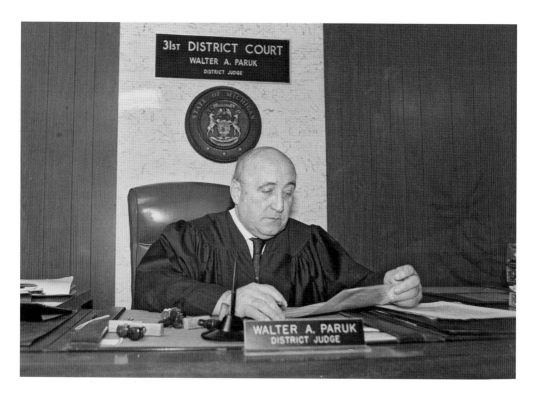

A Man of Integrity

Walter Paruk was one of the most respected judges in Hamtramck's court system. After graduating law school in 1954, he set up a practice in Hamtramck. He was appointed a municipal judge in 1961 when Judge Joseph Lewandowski resigned to run for Congress. Paruk was cited for his integrity in being named municipal judge. He served for decades as municipal, and later, district court, judge. He died in 1994 and his son, Paul, succeeded him as district court judge.

The Look

Ted Mrozowski may have been as well known for his eyebrows as his service in the state legislature. They were a wavy fixture that he flashed to his constituents. Mrozowski, a Democrat, served in the State House from 1969 to 1972 and was a member of several organizations, including the Polish Legion of American Veterans, Polish National Alliance, and Disabled American Veterans.

Challenging Times

Joseph Grzecki Sr. was faced with the challenging task of being mayor from 1963 to 1970, when Hamtramck was suffering a severe drain of residents who were moving to the suburbs. At the same time, the city was launching an ill-fated urban renewal program. But if there were failings in his office, it was not because of a lack of effort or dedication to the city. He really tried to do his best.

An Advocate

Helen Justewicz served on the common council for 18 years beginning in 1969. She helped the city weather some of its most difficult times, including the mismanaged urban renewal program, which had prompted her to enter politics. She was a powerful advocate for senior citizens and the poor. She died in 2003 at age 90 in the Hamtramck home she had lived in for 50 years.

31

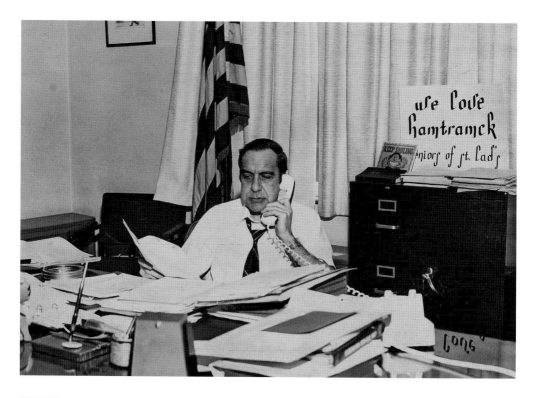

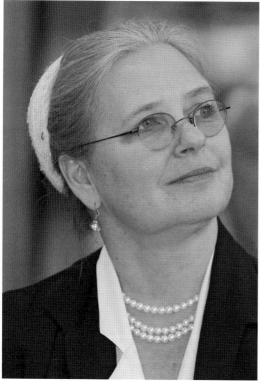

Man for a Troubled Time
Raymond Wojtowicz took the helm as Hamtramck's mayor in one of the worst periods in the city's history. The city was essentially bankrupt, and Wojtowicz was prepared to take the financial steps necessary toward recovery. But he faced fierce opposition from city employees. Even though the city's finances were brought back into order, Wojtowicz couldn't overcome a challenge from popular former mayor Albert Zak who had returned to the political scene in 1973.

The Woman in Charge
Karen Majewski is the first woman to serve as mayor of Hamtramck. She was elected in 2005, and has provided solid guidance through some of the city's toughest economic times. She has shown an exceptional ability to work with state and federal agencies to bring resources to Hamtramck. And she has won wide praise for her sensitivity and ability to work with all the ethnic populations who call Hamtramck home.

A New View

The election of Gary Zych in 1998 ushered in a new era of Hamtramck politics. Zych, a university professor, was seen by many to represent the newer, younger generation of Hamtramck. But he faced the same old problems. As the city teetered toward bankruptcy, a state financial manager was sent in to take control in 2001. Zych served for two terms.

A Doer

He could be abrupt, irascible, even cantankerous, but Gene Pluto knew how to get things done. During a career with the city that spanned three decades, Pluto served as deputy assessor, assessor, councilman, and building inspector. He also owned a popular party store on Caniff Avenue.
He was known to speak his mind and did. He never shied away from an argument. He died in 2007 at age 82.

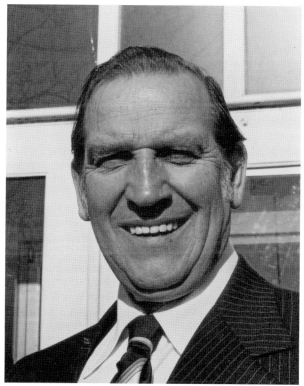

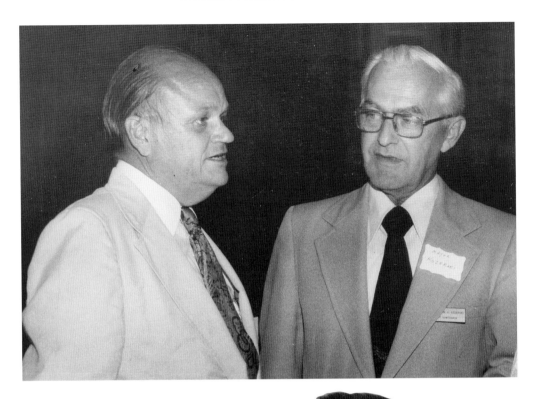

In Congress

Lucien Nedzi (at left in photo, with Mayor William V. Kozerski) served 20 years in Congress, representing Michigan's First Congressional District, which encompassed Hamtramck. Not bad, for a first bid to seek public office. A graduate of Hamtramck High School and the University of Michigan, Nedzi won a tough election in 1961 and became a fixture in Congress until he retired in 1981 and moved to McLean, Virginia.

Voting Guide

Joseph Skomski was better known for what was said about him than anything he ever did. He was elected to the council several times, and in the early 1930s, he won a seat on the council with Boleslaw Lukasiewicz, who was illiterate and barely spoke English. When asked about his position on issues, Lukasiewicz consistently replied, "Me vote like Skomski." But it was Skomski who was indicted on corruption charges, which were later dropped.

Powerfully Polish

Stanley Stopczynski was part of one of the most prominent political families in the area. His father, Stephen Stopczynski, was a long-serving state representative in the 1960s and 1970s, and Stanley Stopczynski served in the House of Representatives from the 1970s to 1990s. Brother Thaddeus also served in the legislature. All were part of what was known for years as "The Polish Corridor," which consisted of legislators of Polish descent.

A Gentle Man

George Tarasuk was an attorney, Rotary Club member, and served on the common council for one term, 1992–1993. He and his father had operated the Metropolitan Iron Works on Conant Avenue before he received his law degree from the Detroit College of Law. But while he had an abundance of professional degrees, it may have been his genial nature that defined him and made him a popular fixture in town.

A Steady Hand

Tom Jankowski was the last mayor to operate under Hamtramck's "strong mayor" system, which granted mayors appointment powers. That changed with the adoption of a new city charter. Jankowski provided steady leadership when the city went through a controversial period regarding a request by local Muslims to announce the "call to prayer" over mosque loudspeakers. The issue was resolved with a show of unity among several religious groups that made the city proud. Jankowski served from 2004 to 2006.

A New Voice

In November 2002, Shahab Ahmed made Hamtramck history when he became the first Asian American to hold elected office in Hamtramck. Ahmed came to America in 1986 from Bangladesh and became involved in the fabric of Hamtramck, forming the Caniff Avenue Improvement Association in the mid-1990s. He later was elected to the city's Charter Revision Commission and then to the common council in 2003. He served on the council until 2011.

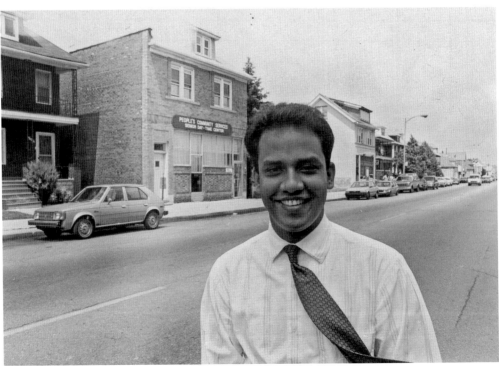

CHAPTER TWO

The Great Educators

Hamtramck educators faced an enormous challenge with the immigrant influx of the early 20th century. Many of the children had never seen doctors or dentists. They were hungry. They didn't even speak English. Clearly, traditional teaching methods wouldn't work. In response, Superintendent Maurice Keyworth drafted a new school code in 1927 that was so progressive, it reads like a modern document today. It set the stage for Hamtramck to develop a reputation as an educational leader in the nation.

Hamtramck also became noted in the areas of bilingual and adult education. The Hamtramck Public Library has always had a close association with the educational system, serving as a vital resource, even today, when the world is at your fingertips through the Internet.

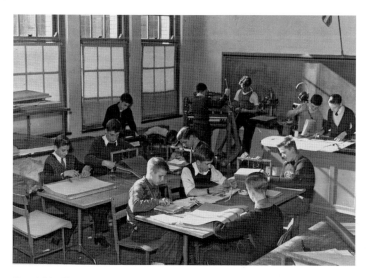

Bookbinding
Students work in a bookbinding class at Copernicus Junior High School in the 1930s.

Maurice Keyworth

No local educator had the impact Maurice Keyworth had during his tenure as superintendent of the Hamtramck Public Schools between 1923 and 1935. When Keyworth was appointed superintendent, Hamtramck was a city virtually in chaos. It had grown from a sleepy farming town of 3,500 people in 1910 to nearly 50,000 in 1923, and all in an area of two square miles. Almost all of these new residents were immigrants who came from Poland to work in the auto factories. They had large families with numerous children. Many of the children had never seen a doctor or dentist; some were mentally handicapped, and few could even speak English. Faced with the task of trying to educate these children, Keyworth understood that the entire education system had to be re-engineered. Accordingly, he brought doctors, dentists, and counselors into the schools. He began huge adult education and bilingual programs to educate the parents, and he initiated such concepts as public relations programs and parent outreach activities. The Hamtramck Public School Code of 1927, which he essentially drafted, was so innovative that it was adopted in part by school districts across the nation and some foreign universities. Even today, it reads as a remarkably progressive document. Keyworth attracted national attention for his educational programs and the amazing successes he achieved. In 1935, he was elected superintendent of schools for the State of Michigan. But tragically, just a short time later he was killed in a car crash while touring schools in northern Michigan. His body was laid in state at Hamtramck High School. Thousands of people from across Michigan, including educators from other communities, came to pay their respects. Under Keyworth's leadership, the Hamtramck school system was recognized as among the best in the nation.

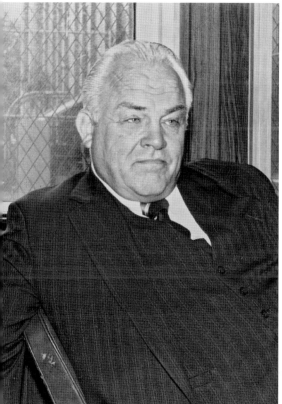

Early Educator

Hamtramck was still a farming community when E. (Ellis) G. VanDeventer was named superintendent of the Hamtramck Public Schools. There wasn't much for him to oversee in the early years. Hamtramck had only a few hundred residents. But after 1910, with the opening of the Dodge Main factory, Hamtramck's population exploded. VanDeventer oversaw the building of several schools, including Hamtramck High School and Pulaski and Pilsudski Schools. He was replaced by Maurice Keyworth as superintendent in 1923. VanDeventer, however, remained with the district as purchaser of supplies. He died in 1944 at age 79. He's seated at the table in photo.

Rising Above

Clarence Pilartowicz had a hard start to life. His father died while he was still a boy, and when the family returned home from the funeral they found the landlord had put their belongings on the street. The family was taken in by friends, and Pilartowicz vowed then that he would rise above his poor beginnings. He did, eventually becoming superintendent of the Hamtramck public schools from 1976 to 1986. He died in 2001 at age 77.

39

Dean of Education

Public school superintendent E.M. (Edmund Martin) Conklin had the rare distinction of being beseeched to remain on the job by the school board when he announced his retirement in 1960 after serving as school chief for five years. Conklin relented, for a short while. But even when he did finally leave, he kept active in the schools as a part-time counselor. Conklin was born in Howell, Michigan, on November 27, 1885, but took pride in the fact that his "adopted city" of Hamtramck felt so strongly about his performance. Before coming to Hamtramck in 1923, Conklin was principal of the Howell High School for five years. In 1920, he became principal of Hamtramck High School. This was during a period of unprecedented growth in the schools as the community was being flooded with new immigrants. Conklin excelled as principal of Hamtramck High School but left the district in 1945 to become director of veterans' counseling for Hamtramck, where he helped aid and rehabilitate 8,000 war veterans. In 1955, he returned to education, being named superintendent of the Hamtramck Schools. And as a counselor following his tenure as superintendent, he had a major impact on the dropout rate, reducing it to just 11 students in one year. His philosophy for succeeding with the students was simple: "Boys and girls must be made to feel they are wanted and that someone cares about them. This probably is the most important thing we can do," Conklin said. He also helped hundreds of students find jobs or go on to higher education. One of his great success stories was that of Emil Konopinski, who became a noted physicist and helped develop the atomic bomb (see chapter 8). Conklin arranged for him to receive a scholarship. In recognition of Conklin's service, January 17, 1962, was named E.M. Conklin Day and he was honored at an afternoon tea at Copernicus Junior High School and a dinner at the Knights of Columbus Hall.

Beyond Books

Bea Adamski spent a good part of her adult life working with the Hamtramck Public Library, where she served as head librarian for 21 years before retiring in 1977. She was named as Librarian of the Year by the State of Michigan in 1971 for her innovative approach to making the library a center of the community, not just a repository of books. She died in 2002 at age 85.

Extraordinary Teacher

When Bea Olmstead was director of instruction in the Hamtramck Schools in the early 1960s, she was twice listed in *Who's Who in American Education*—for good reason. Olmstead was a great presence in the schools and was known throughout the educational community for her expertise, especially in the area of curriculum. She assisted with the first curriculum workshop held in Hamtramck in 1963 and was involved with audio-visual education.

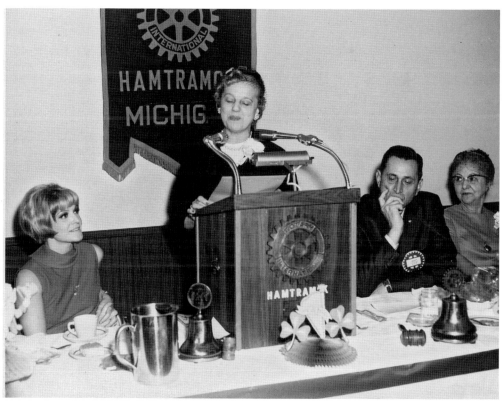

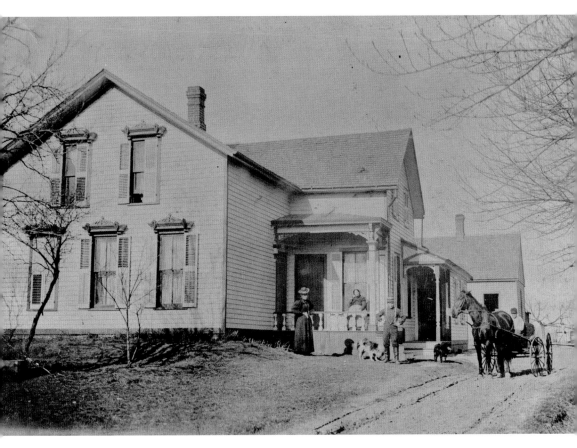

School Legacy

Robert Dickinson grew up on a farm at Holbrook and Conant Streets. Born in 1870, he saw Hamtramck grow from a farming community to an industrial city. He operated a successful dairy and later became a member of the Hamtramck School Board. Dickinson School is named after him and built on the site of his former farm.

Amazing Stories

Tamara Sochacka has spent more than a dozen years as director of the Hamtramck Public Library. But her life story reads like a book. She is a poet, writer, journalist, and activist who was imprisoned for her participation in activities to overthrow the Communists in her native Poland. In the more sedate setting of the library, she organized the first public computer lab and has coordinated a seemingly endless stream of events for the public.

CHAPTER THREE

Homegrown Stars

While Hamtramck has been a gritty industrial town for most of its modern existence, it produced its share of artists and entertainers. Some went on to achieve major success in Hollywood and on Broadway. Tom Tyler was one of the leading stars in westerns. John Hodiak was an A-list actor who starred in major Hollywood films. And Gail Kobe excelled in front of and behind the camera. Most never lost touch with their old hometown, frequently returning to receive a celebrity's welcome. All serve as a source of pride for the community and in a way are immortal, for their works continue to be shown even though some have been gone for decades.

The Spotlight
Dancers, singers, actors, and many more have stood in the city's entertainment spotlight.

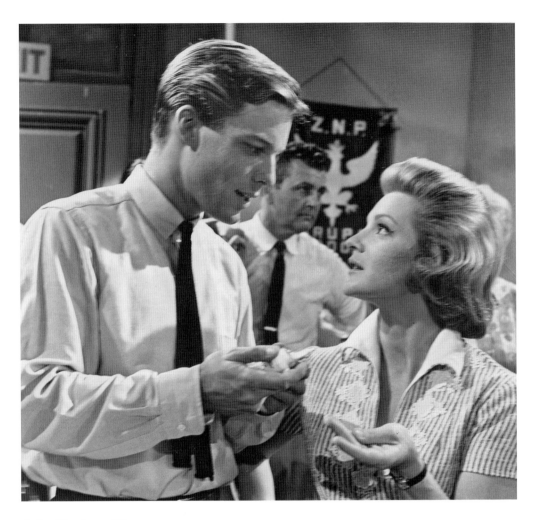

Actor/Producer/Star

Gail Kobe achieved great success in Hollywood. She began her career in show business at age six, performing in a Polish dancing troupe. She later shifted her focus to acting and attended the University of California, Berkeley, where she majored in theater arts and drama, and where she was named the Actress of the Year in 1953 and 1954. She performed with the respected Pasadena Playhouse and came to the notice of legendary director Cecil B. DeMille. He cast her in a small role in the epic *The Ten Commandments*. That was followed by roles in more than 100 TV shows, including *The Twilight Zone*, *The Outer Limits, Gunsmoke*, and *Dr. Kildare*. In an episode of *Dr. Kildare*, entitled "Immunity," she portrayed a Polish doctor, and won praise for her sensitive performance and presentation of Polish culture in a positive light. She is pictured here with Richard Chamberlain, as Dr. Kildare, in the "Immunity" episode. Along with extensive theater and TV performances, Kobe fashioned a second career as a producer, particularly of soap operas. She produced such shows as *The Guiding Light* and *Texas*, along with popular non-soapy favorites like *The People's Court*. She is commemorated with a star on the Palm Springs Walk of Stars and has won many awards for her extensive body of work. She was the subject of articles at least twice in *TV Guide*, and garnered much press over the years not only for her performances but also for her skills as a producer. Kobe has maintained strong ties to Hamtramck over the years. Her sister, Bea Adamski, was the longtime director of the Hamtramck Public Library, and Kobe has returned to the city for special occasions.

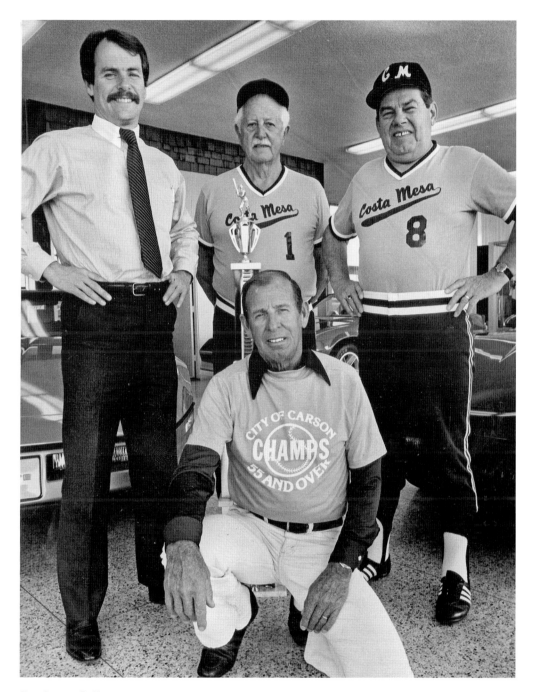

Persistent Sailor

"There is no such thing as smooth sailing" in the acting business, Peter Similuk said. He would know. He worked hard to break into show business, and achieved some success, appearing in the 1948 film *A Foreign Affair*. But he also played a role in the cult classic *The Hideous Sun Demon*. And he played baseball with the Costa Mesa team. Similuk is at right. With him are (from left) Pat Connell, Holmes Ellis, and Bob Burrell (in front).

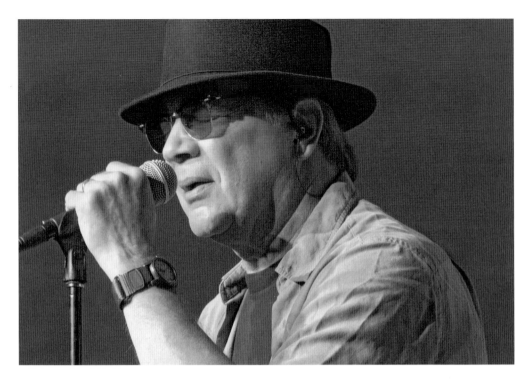

A Hamtramck Wheel

"Devil with a Blue Dress On" is a genuine Detroit rock 'n' roll classic. It was just one of a string of hits performed by Mitch Ryder and the Detroit Wheels, a legendary rock band. Ryder was born in Hamtramck in 1945, and has been performing since 1962. Among his other hits are "Jenny Take a Ride!" and "Sock It to Me—Baby!" Mitch Ryder and the Detroit Wheels were inducted into the Michigan Rock and Roll Legends Hall of Fame in 2005. Long separated from the Detroit Wheels, Ryder continues to perform at many venues. (Courtesy of Jason Engstrom.)

"A Little Hassle"

He won two Grammys in the 1980s, but to Leon Zarski, all the attention he received for the honors was just "a hassle." Zarski wrote scores of songs, but "A Polka Just for Me" and "I Remember Warsaw" both won Grammy awards. Here he is holding a copy of his work, "Our Pope, Our Shepherd," written for Pope John Paul II's visit to Hamtramck in 1987.

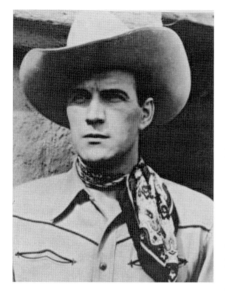

Captain Marvel

Today his movies seem quaint, at best. But in the 1930s Tom Tyler (born in 1903 as Vincent Thomas Markowski) was a certified box office star. A one-time weight lifter who worked at an area auto plant, Markowski was noticed by a talent scout at a weight-lifting competition held at Martha Washington Theatre. He headed to Hollywood, but had trouble breaking into show business. After serving in a variety of jobs, including sailor, he got a break at a major studio where he was rechristened as Tom Tyler and starred in innumerable B westerns, like *The Unconquered Bandit*, and *God's Country and the Man*. But he captured the hearts of kids across America for portraying a superhero in the Saturday matinee series *The Adventures of Captain Marvel!* He transformed into his superhero persona with the power of the word "Shazam!" which stood for "Solomon, Hercules, Atlas, Zeus, Achilles, and Mercury." He also had a short, but memorable role in the John Ford classic *Stagecoach*. Tyler didn't forget the kids at home, occasionally coming back to Hamtramck to share cookies and milk with his young fans at the St. Anne's Community House. On one occasion, when he entered the room he was met with a thunderous cheer by the kids, according to a newspaper report. A degenerative heart condition cut his career short and he returned to the Hamtramck area by the early 1950s to live with his sister. He died in St. Francis Hospital on May 1, 1954. He was just 50.

An A-List Star

A 1932 graduate of Hamtramck High School, John Hodiak established himself as an actor locally before finding success in Hollywood. In the 1940s, he starred in major pictures, including Alfred Hitchcock's classic *Lifeboat*. Ranked as an A-list actor, Hodiak enjoyed great success in films and on Broadway, but died suddenly in 1955 at age 41 of a heart attack. He was married to actress Anne Baxter.

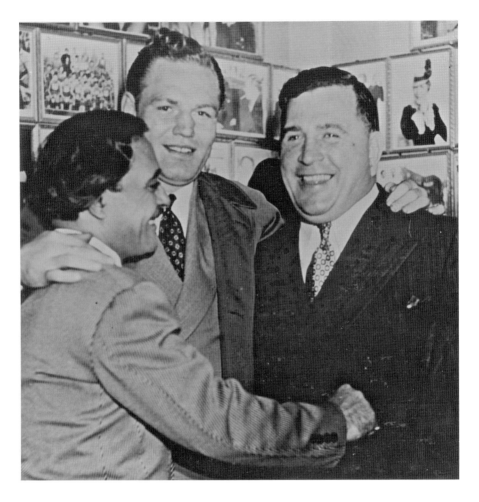

That's an Entertainer

"Good evening ladies and gentleman. It's showtime at the Bowery," and with that, the drums rolled and the horns roared and the show started at Frank Barbaro's legendary Bowery nightclub. Barbaro owned the immensely popular Bowery on Jos. Campau Avenue. In its heyday, the 1940s and 1950s, the Bowery hosted some of the leading entertainers in America. The lineup is impressive: Martha Raye, Tony Martin, Ella Fitzgerald, Jimmy Durante, Gypsy Rose Lee, Milton Berle, the Three Stooges, and Sophie Tucker, among many others. Guests would show their appreciation by tapping on the tables with small sticks capped by wooden balls. Why? Just because. Barbaro made sure that a visit to the Bowery was an experience. While you were watching the show, you could order a photo of your table from a roving photographer, which would be presented to you in a custom folder frame. Barbaro didn't limit the entertainment to singers and comics. He also would sponsor boxing tournaments at the Bowery. After he and his wife divorced in the early 1950s, she was awarded the Bowery, but it failed after a few years. Barbaro opened another place on Cass Avenue in Detroit, but then slipped into obscurity. Barbaro is at left in the photo. At right is his bodyguard, John DeGutis, and in the center is Lee Savold, winner of a boxing tournament held at the Bowery. The building that housed the Bowery burned soon after it was closed. It was demolished and later turned into a parking lot used by Woody Pontiac, another Hamtramck landmark business. But it isn't gone without a trace. The roofline imprint of the Bowery is still visible on the building that once adjoined it. Its ghostly image is a wispy reminder of what was once the most rollicking spot in town.

CHAPTER FOUR

On the Field

A small set of tennis courts occupies a space in Veterans Memorial Park bordering Jos. Campau Avenue. Just behind them is a cluster of baseball fields. None of them look particularly impressive, yet all had an impact on the world of sports. For years Jean Hoxie taught youngsters to hit a tennis ball, and some went on to play and win at Wimbledon. The ball fields were used by the Hamtramck Little League and Pony League teams, which won world championships in 1959 and 1961, respectively.

In almost all sports, Hamtramckans excelled. Walter Roxey was a terrific wrestler, while Rudy Tomjanovich played for and coached great pro basketball teams. They were great competitors and even better champions.

Veterans Memorial Park
Sliding into home at one of the fields at Veterans Memorial Park is just one recreational activity the city has sponsored.

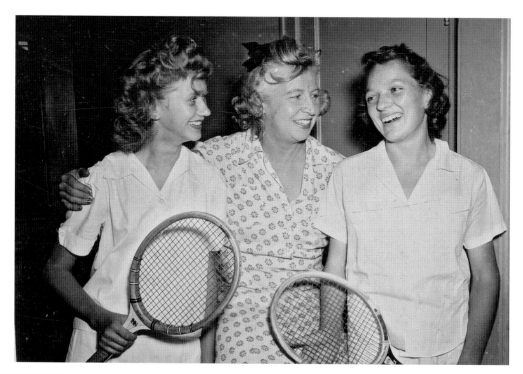

All Aces

Jean Hoxie (center) achieved legendary status in the world of tennis. On the courts at Veterans Memorial Park, she coached thousands of youngsters, most of whom never got beyond the park fence. But a few, like Jane "Peaches" Bartkowicz, went on to win at Wimbledon. And dozens went on to play in professional leagues. In 1948, Hoxie was featured in *American Lawn Tennis* magazine. The article was reprinted in the September 1948 issue of *Reader's Digest*, under the title "Tennis Teacher Extraordinary." She is pictured with Stephanie Prychitko (left) and Gloria King at the Hamtramck Open Michigan Girls Tennis Tournament. Hoxie died in 1973.

Young Star

A young Ted Jax (at right in photo) was already playing tennis under the tutelage of the great Jean Hoxie. He would go on to be one of her shining stars, winning four championships in 1946 when he was just 14. He would win many more tournaments, including the City League Singles crown. He's pictured with Hoxie, Johnny Koliba, and Mary Ann Randazzo in 1943.

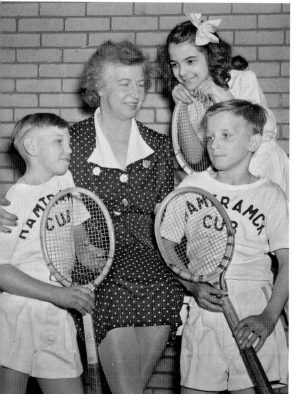

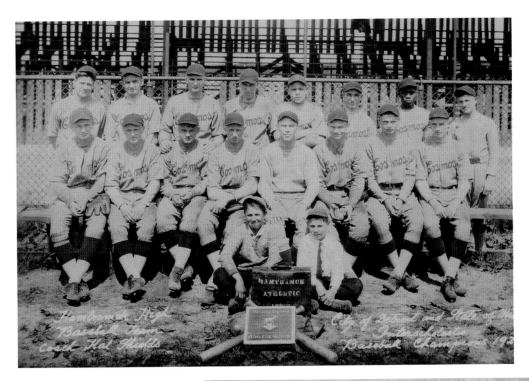

Champion Coach

Hal Shields (at center in photo) always wanted to have a career in athletics. Although he played minor league baseball in Oklahoma for a while, he excelled at Hamtramck High School where he became an extraordinary coach in baseball and football. During his 10-year tenure as HHS football coach he won 60 games, lost 16, and tied eight. His teams in 1930, 1934, and 1935 went undefeated.

The Champ

Walter Roxey went from being a social science teacher at Copernicus Junior High School to the light heavyweight wrestling champion of America in 1935. It was just one of a number of wrestling titles Roxey would pick up during his career. He also served as the school district's recreation department director for a time. Roxey (left) is pictured with Johnny Gorsica and Julian Bielat of Liberty State Bank.

Ace of Spies

Fred Kovaleski's life reads like the pilot of a TV series. In fact, it may have been one. In the 1960s, Robert Culp and Bill Cosby starred as undercover spies posing as tennis pros in the TV series *I Spy*. That mirrored Kovaleski's real life in the 1940s and 1950s, when he traveled the world playing tennis while secretly working as a CIA agent. Kovaleski was one of tennis teaching great Jean Hoxie's brightest pupils. In high school, he was Metropolitan League singles champion and he was on the Hamtramck High School championship tennis squads in 1940 and 1941. He went on to play at the College of William and Mary, but soon left to enlist in the Army where he distinguished himself in the 11th Airborne Division as a paratrooper. After being discharged in 1946, he returned to William and Mary where he rejoined the tennis team, which won the NCAA national championship in 1947 and 1948. Kovaleski was authorized by the United States Lawn Tennis Association to play in its tournaments. He was invited to play in Europe and Asia including playing at Wimbledon, where he was seeded 13th. Along his travels, he met Joseph Sparks, the counselor of embassy in Cairo, Egypt, who offered to introduce him to officers at the State Department should he wish to join the foreign service. In 1951, he contacted Sparks again, who arranged interviews with the State Department, which in turn led to him being recruited by the CIA. In 1954, he returned to Cairo, undercover as a tennis player but carrying out covert operations for the CIA. Some of his exploits read like scenes from a spy novel, as he helped smuggle Russian defectors into American hands. Eventually, Kovaleski met a woman of Russian descent, and when they wanted to get married, she couldn't pass a CIA security test. Kovaleski resigned from the CIA. He later worked for Pepsi Cola as a field representative and then for Revlon Cosmetics in Australia. In 1971, after 17 years abroad working in countries like Egypt, Lebanon, Sudan, Aden, South Africa, and Australia, Kovaleski moved back to America where he became Revlon's vice president for Europe and the Middle East based in New York City. He and his wife settled in Washington, DC, and then New York City. Now in his 80s, he continues to play tennis. In 2009, he won the US Tennis Association's Men's Grass Court Championship for players age 85 and older. At last check, he was ranked No. 1 in the world for his age group.

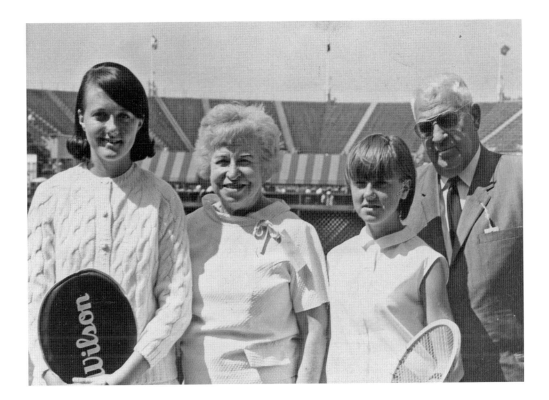

A Peach

It's a natural: Mention tennis great Jean Hoxie, and you're likely to immediately picture her prize pupil Jane "Peaches" Bartkowicz. Peaches—whose sister, Christine, was known as "Plums," by the way—was the pride of the Hamtramck tennis program, which was led by Hoxie. Peaches was the daughter of poor immigrant parents and moved to Hamtramck at age five. She soon took an interest in tennis, and Hoxie took an interest in her. By age eight Peaches won the national indoor under-13 title. And she took off—winning more than 100 trophies in quick order in a host of tournaments. Soon the Western Lawn Tennis Association ranked her as No. 1 in three groups: 14-, 16- and 18-and-under, the first player to win that multiple recognition. That was a key factor to her being invited to Wimbledon in 1964. There she won the girls title by defeating Elena Subirats of Mexico, 6-3, 6-2. Peaches had an overpowering forehand and had learned well from Hoxie the importance of concentrating and how to mix and pace her shots. "She has all the shots, with freehand, drop shot, lob and smash," Hoxie said. And she had terrific power. "You hold up a tennis racket and she'll knock it out of your hand from across the court, and if you hold it too tight, she'll break your wrist." Peaches' victory at Wimbledon drew national attention and was a source of pride for all of Hamtramck. "You have proved again that when it comes to sports champions, Michigan has a commanding lead," Gov. George Romney said. "Our country's tennis future brightened considerably by your win." "Jane 'Peaches' Bartkowicz is a tribute and inspiration to the youth of our great nation. This victory is a distinct honor to the entire United States," Congressman Harold M. Ryan said. Peaches went on to win the singles title in Canada in 1968 and reached the quarterfinals at the US Open in 1968 and 1969. She played again at Wimbledon in 1969, where she and Julie Heldman upset defending champions Billie Jean King and Rosie Casals. Peaches also won silver and bronze medals at the 1968 Olympics in Mexico City. Peaches retired from tennis in 1971, but has left her mark in the sport. She was inducted into the United States Tennis Association/Midwest Hall of Fame and the Michigan Sports Hall of Fame. She's at left with Hoxie; sister, Plums; and Hoxie's husband. Jerry.

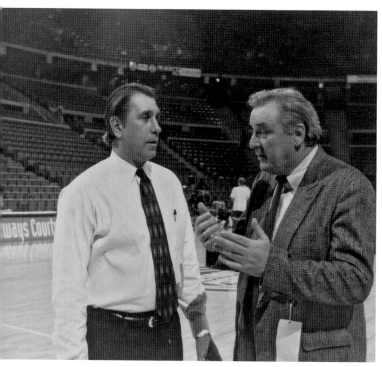

A Rocket Star

From the basketball courts of Hamtramck to the NBA, Rudy Tomjanovich was probably the best netter Hamtramck ever produced. He was drafted by the San Diego (later Houston) Rockets in 1970 and remained with them his entire career, averaging 17.4 points a game. He appeared in five All-Star games and was the third leading scorer for the Rockets. He later coached the team, as well as the Los Angeles Lakers. He's shown here with Mayor Robert Kozaren, who was nearly as tall as the six-foot-eight Tomjanovich and with whom he played basketball in Hamtramck.

Champion Coach

As coach of the Hamtramck High School basketball team, Floyd Stocum garnered the first athletic championship ever won by a Hamtramck school. That was in 1926, early on in his long and illustrious career with the schools in which he coached every sport possible. And he had at least one championship team in every sport he coached, including soccer, baseball, and track. In the photo, Stocum (center) is with football co-captains Chester Tzay (left) and Mitchell Berlin.

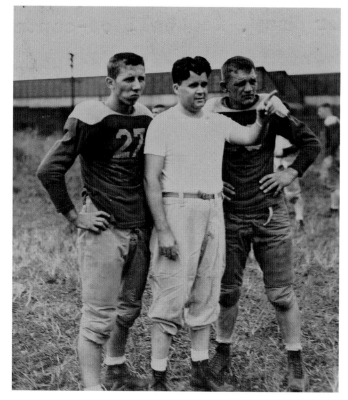

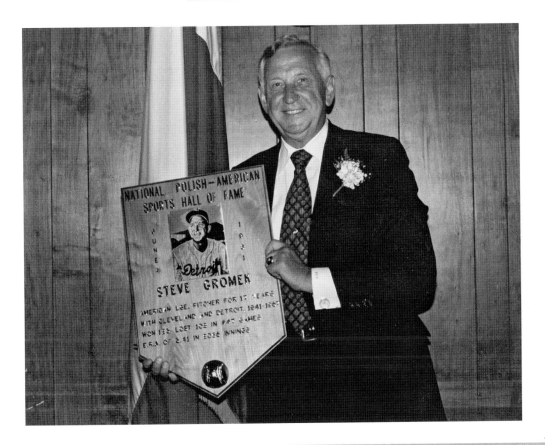

First on Base

The peak of Steve Gromek's career probably was a seven-hit win over the Boston Braves in the 1948 World Series. Gromek was an ace pitcher with the Cleveland Indians at the time. But he later would come home to pitch four seasons with the Detroit Tigers. He was the first Hamtramckan to reach the major leagues, and he was inducted into the National Polish-American Sports Hall of Fame. He died in 2002 at age 82.

Team Player

For 30 years, Mitchell Wysocki served as director of the Hamtramck Recreation Department beginning in the 1950s. But he was a familiar figure at many sports venues, including the Playdium Bowling Center, where he founded the mammoth Citizens Singles Bowling Classic. He also was a member of the Briggs Beautyware softball team and even the Hamtramck ping-pong team. He died in 1999 at age 78.

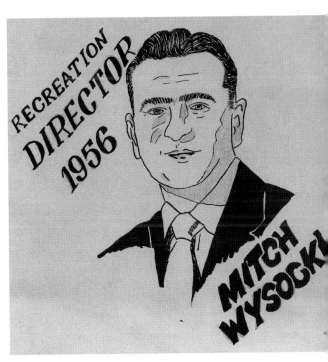

Mr. Softball (ABOVE)
Tony Lutomski was a successful attorney, but it wasn't unusual to see him watering the grass at the softball fields. His real love was softball. Over 40 years, he sponsored more than 100 softball teams and organized two leagues. For his efforts, he was inducted into the American Softball Hall of Fame, the National Polish American Sports Hall of Fame, and the Hamtramck High School Hall of Honor. He died in 1991 at age 75.

Around the Leagues
Born in Hamtramck in 1953, Bill Nahorodny was 23 years old when he was called up to play in the major leagues. A catcher, he played for the Philadelphia Phillies, Chicago White Sox, Cleveland Indians, Detroit Tigers, and Seattle Mariners. He was active from 1973 to 1985.

The Coach—The Champ

Almost every aspect of sports in Hamtramck was touched by Artie May. May played football at Hamtramck High School, then earned varsity letters in football, baseball, and track at Western Michigan University. In 1947, he returned to Hamtramck and became director of programs for the Hamtramck Recreation Department, where it didn't take long for him to take Hamtramck teams to seven state championships. He managed the Pony and Colt baseball leagues and T-ball from 1954 to 1966. In 1955, his Colt League team went to the World Series. In addition, May was a manager with the Detroit Amateur Baseball Federation (DABF) where he led the 1950 championship team and 1951 DABF runner-up team. For his efforts he was named DABF All Star Coach for both years. In 1957, May was named Hamtramck High School head football coach, and took the team to an incredible 20 consecutive league victories. And during his career, which spanned 40 years—and included three retirements—May coached football, track, cross-country, basketball, baseball, and tennis. In 1980, he was inducted into the Hamtramck Sports Hall of Fame. He also was inducted into the Hamtramck High School Athletic Association Hall of Fame in 1984. May was one of the founders of the Metro Soccer League and promoted girls sports. Off the various fields he knew so well May was instrumental in the designing of the Hamtramck High School Community Center and its programs. He oversaw the development of the Conklin Hall in the center, named in honor of former superintendent E.M. Conklin. In 1988, May was honored at a special tribute. The commemorative booklet issued in conjunction with the tribute included a heartfelt thanks from a former player. It read, in part: "You didn't gossip and you never lied to us. You never noticed a difference in our size, or how we pronounced our last name, or a difference in the shade of our skin; and, as a result, we saw no difference in each other . . . You dealt with us as young boys full of raw energy and misinformation, and you shaped us into young men of sinew who could perform on the field as one well-practiced unit. We love you for your vision and efforts, which made winners of us all, on the field and off."

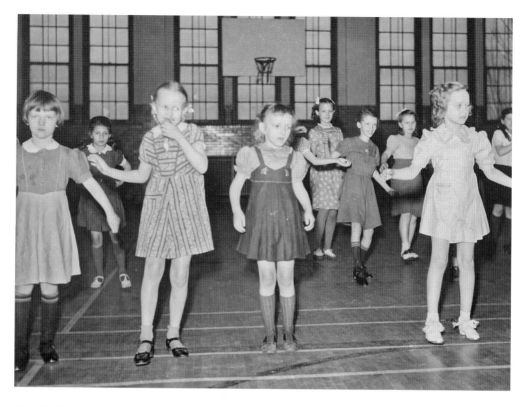

Play Ball! And So Much More

When Hamtramck experienced its phenomenal growth in the second decade of the 20th century, little thought was given to recreation programs. The then-village council was wholly inadequate to deal with providing basic services, let alone recreational activities. For the most part, kids played in empty lots and on the streets. It was dirty and dangerous and unacceptable. When the Tau Beta social organization came to Hamtramck in 1916, it began offering some basic recreational services ranging from providing a playground to sponsoring theater productions. But after Hamtramck became a city in 1922 and its population was heading upwards of 56,000 people, it was time for the city to finally step in. In 1925, the city council authorized the formation of a recreation commission. That was soon combined with the school district operations to form the city's first recreation department. In addition to offering standard sports activities, the recreation department sponsored such programs as tap and ballet dancing lessons and slimming classes for women. Men could flex their muscles in a weight lifting program. The department also sponsored a Junior Olympics, Midget Bowling, and advanced swimming. Providing space for all these programs was a variety of excellent facilities. Keyworth Stadium was built in 1936 with a federal Works Progress Administration grant. Baseball diamonds, including one with lights, were built at Veterans Memorial Park, and smaller parks and playgrounds were established around the city. They were supplemented with school facilities, such as the swimming pool at Hamtramck High School. On the fields and courts, participants could get some of the finest instruction anywhere. Jean Hoxie trained Wimbledon champions at the tennis courts at Veterans Memorial Park, and the Little League and Pony League baseball teams achieved national honors. While not every kid was a champ, all could find something to do in the recreational program. Through the years, the department took thousands of kids on field trips to Bob-Lo Island and the Henry Ford museum, as well as a host of other places across the metro area. In 1979, the department opened a new, modern community center next to Hamtramck High School, the former Copernicus Junior High School. It, along with the recreation department operations, continues to function today, providing fun for a continuing stream of new residents.

The Greatest

It's not often that one can point to anything and say this is the best there ever was. But Art "Pinky" Deras was the best Little League player in the history of the sport. That's a bold claim as an estimated 30 million kids have played Little League. However, his statistics, even for Little League, are staggering. Heading for the Little League championship in 1959, Deras, as pitcher, tossed 18 complete games in 18 starts. That included 16 shutouts, 10 no-hitters, and 298 strikeouts, and he allowed just 10 walks. As a hitter, he posted a .641 average for the season including 33 home runs and 112 RBIs. Deras led the Hamtramck team into the 1959 finals, propelling Hamtramck to a one-hit, 5-0 shutout against Puerto Rico, then hit a grand slam homer in a 7-0 victory over Honolulu to lead Hamtramck to a 12-0 rout over Auburn, California, for the championship. The performance even earned him a hug from Mayor Al Zak. But Deras didn't stop with the Little League title. Two years later he led the Hamtramck Pony League team to another world championship. A newspaper headline from the time summed up the repeating story well: "Same Old Story: No-Hitter for Pinky Deras." In that particular game, Deras threw 18 consecutive strikeouts leading Hamtramck to a 13-0 win over the opposition. But his batting average was down a bit—to .595. Deras had somewhat of a built-in advantage. While playing Little League he stood five-foot-eight and weighed about 135 pounds, which put him a head above most of the other players. But the size advantage alone couldn't account for all of his remarkable skills, including his razor sharp pitching aim and fastball that was described as "a blur." Deras didn't win the games by himself, of course, despite his impressive statistics. And he never showboated. With typical modesty, he always credited his teammates for their success. Deras later tried his hand at pro ball, spending five seasons with the St. Louis Cardinals. But the magic just wasn't there anymore. He left baseball, but was never forgotten. In 2011, he was inducted into the Polish-American Sports Hall of Fame, and a street in Hamtramck was rededicated in his honor. And finally, he and his teammates were featured in a documentary, *The Legend of Pinky Deras: The Greatest Little Leaguer There Ever Was.*

Those Championship Seasons

Twice Hamtramck climbed to the top of the sports world. In 1959, the Hamtramck Little League team made easy work of the Puerto Rico, Honolulu, and California teams to take the world title. Two years later, the Pony League squad, which had been formed in 1954, and captured state titles in 1953 to 1958, took the world championship. In both cases, the teams sent the city into open joy. There were parties and parades honoring the squads. The Little League team members even made a guest appearance on the Lawrence Welk TV show, and the national spotlight shone on the city. The Little League team was recognized in the US Congressional Record, which carried a speech presented by Rep. Thaddeus Machrowicz. He praised the team and the city, concluding with the words, "Hail to Hamtramck, the city of champions."

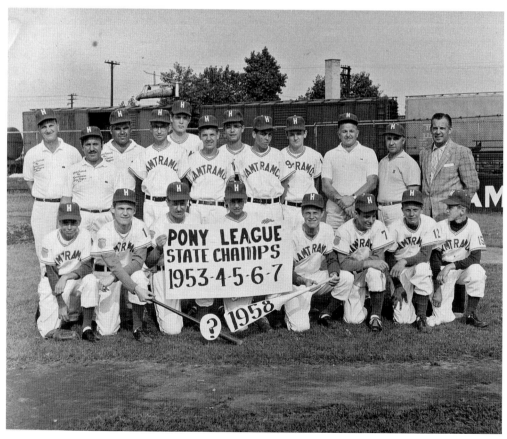

CHAPTER FIVE

Selling in the City

The heart of the Hamtramck business district has long been Jos. Campau Avenue. Although it still is a busy shopping district, in its greatest days, from the 1920s to the 1960s, the Campau strip was the second most popular shopping district in southeast Michigan. Only downtown Detroit did more business. The key to Campau's success was its businesspeople. They specialized in top-quality merchandise, some of which was hard to find anywhere else.

But beyond what was on the shelves and in the windows, it was the businesspeople who made the stores more than buildings where goods were sold. Guys like Max Rosenbaum and Woodrow Woody made big and small contributions to the community, ranging from sending poor kids to camp to helping build the Hamtramck Public Library building. Other businesspeople made their own contributions to the welfare of the town in a time when profit wasn't the only motivation or measurement of success.

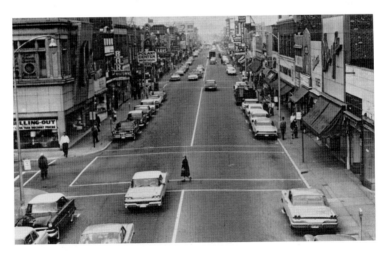

Jos. Campau Avenue
For decades, Jos. Campau Avenue has been the core of Hamtramck's shopping district. It has been the workplace of many colorful characters.

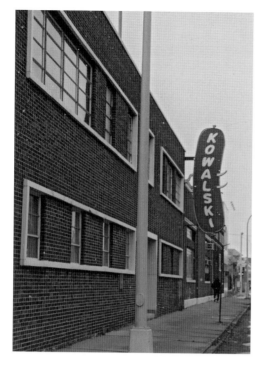

"Smaczne" (ABOVE AND BELOW LEFT)
Zygmund Kowalski came to America from Poland when he was 17 years old. He and his wife, Agnes, made their way to Detroit where they opened a small grocery store. But their real talent was in smoking meats, and the demand for their products soon overshadowed other groceries. On May 4, 1920, Zygmund and Agnes founded the Kowalski Sausage Company. It grew, despite the challenges of the Great Depression. In the 1940s, the company opened its familiar plant on Holbrook Avenue in Hamtramck. Zygmund died on March 29, 1956, and by then eldest son, Stephen, was in charge of operations. He helped lead the company to the success it continues to enjoy today. For years it advertised itself with the tag "smaczne," which is Polish for "delicious."

Good as Gold (ABOVE RIGHT)
Max's Jewelry store on Jos. Campau Avenue was one of the landmark stores in Hamtramck. And Max Rosenbaum was a leading merchant for decades. Rosenbaum and his store epitomized what was best about the shopping district. The store offered top-quality merchandise, and Max had a true community spirit, becoming involved in numerous activities, including sending hundreds of kids to summer camp. Rosenbaum came to America from Poland in 1911 and founded the first of his jewelry stores in 1913. Eventually he would have three stores, including the main store in Hamtramck. Along with jewelry, Max had a camera and photo department, tape recording equipment, a complete optical and watch repair service, and a large gift department in the basement.

Smokin' (RIGHT)
Kowalski wasn't the only company that produced fine-quality meats in Hamtramck. Jaworski Sausage also was a perennial favorite, operating out of a small store on Jos. Campau. This view dates from about 1923 and shows what a limited offering there was. Along with Kowalski and Jaworski, the Kopytko market, as well as Srodek's, Ciemniak's, Bozek's, and the Polish Market, established the city's reputation as the place to find supplies for an ethnic feast.

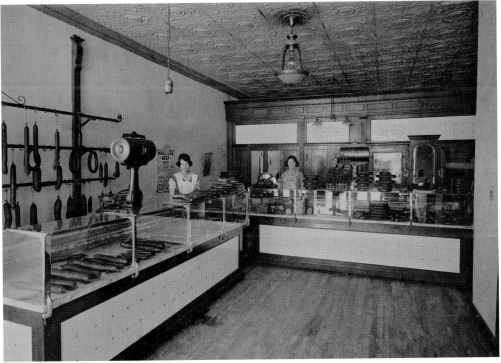

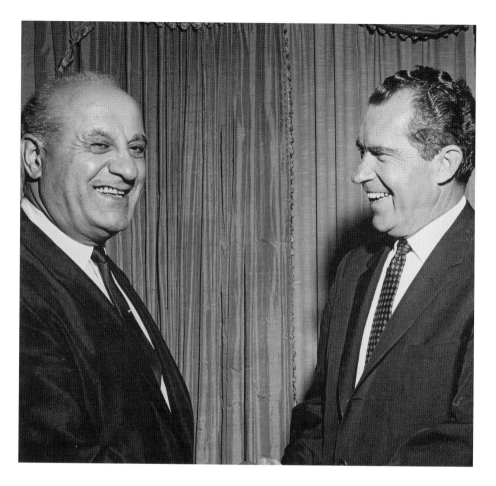

"Hello, Folks!"

He was one of a kind—Woodrow W. Woody broke the rules. He was a staunch Republican (that's him with President Nixon) in a town that voted overwhelmingly Democratic. He sold Pontiacs in a city dedicated to Dodges, yet he succeeded at everything he did and was a beloved figure in the community. Born Woodrow Wilson Shikany in Lebanon, he came to America in 1911. He grew up in Minneapolis where he sold newspapers. After dropping out of high school, he came to Detroit where he spent several years working in an auto plant. He applied for a General Motors dealership in 1939 and opened a Pontiac dealership in Hamtramck in 1940 on what was known as Automobile Row for its large number of dealerships. Woody Pontiac would become one of if not the most successful Pontiac outlet in the nation, ultimately selling an estimated 100,000 cars over its 60 years in business. Sales were helped through the years by Woody's folksy commercials, that featured him saying, "Hello, folks," and "See you soon." They became iconic hallmarks of the local TV scene—as did he. But Woody wasn't limited by the walls of his dealership. He contributed to many city causes, and was a moving force behind building the Hamtramck Public Library building on Caniff Avenue. When the city faced one of its periodic financial shortfalls, Woody came forward with a $10,000 check to pay his taxes early and allowed the city to meet its payroll. Woody also funded a medical clinic in the village in Lebanon where he was born, and he established the Hillcrest Country Club in Clinton Township and donated property to the township to create Woodrow W. Woody Park. But Hamtramck was his real love. Long after most of the other dealerships closed, Woody remained. Woody was devoted to Hamtramck, and worked every day at his dealership until he retired at age 92 in 2000. He died two years later.

Principal Owner

It's a long way from England to Hamtramck, but Henry Velleman made the transition smoothly. He came to Detroit in 1971 as principal owner of a new Detroit hotel and shifted to the real estate industry in 1979 when he bought a business in town. Then he methodically bought a series of business buildings in Hamtramck, rehabilitated and leased them. Ultimately, he came to own a good portion of Jos. Campau.

Polish Treasures

When Joan and Ray Bittner bought the Polish Art Center on Jos. Campau Avenue in 1973, it was already an established business. But they turned it into a destination for visitors from across the country. The store has been featured on national TV shows and a wide variety of media for its impressive imported items from Poland. Their customer base reaches around the world.

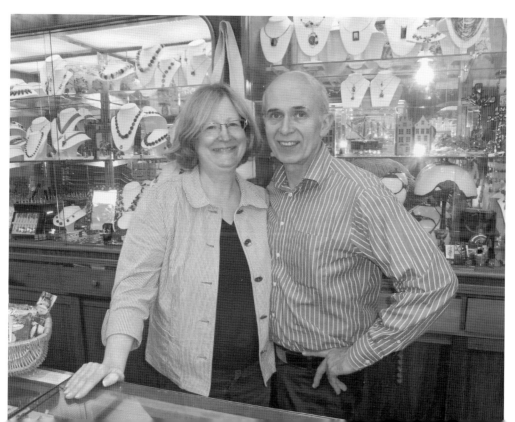

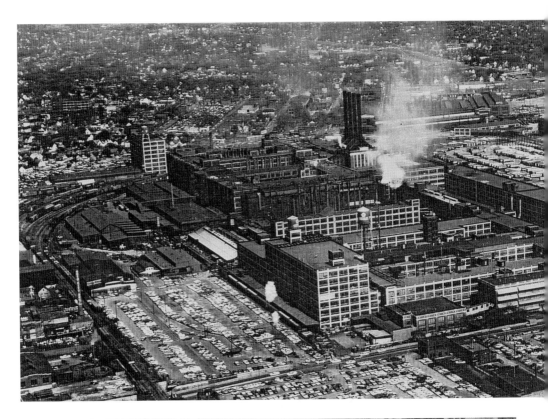

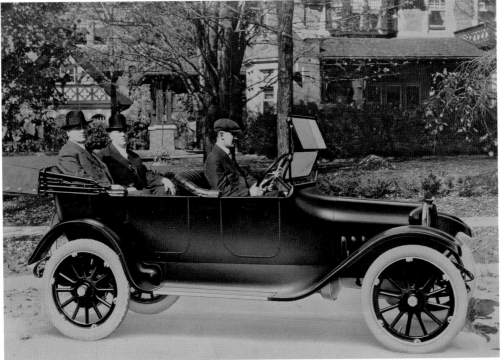

The Dodge Brothers

They were two engineers from Niles, Michigan, who had an exceptional way with mechanical devices—and business. John Dodge was born in 1864 and his brother, Horace, was born four years later. As children, they learned the fundamentals of engineering, working at their father's machine shop. The family moved several times before settling in Detroit. All the while John and Horace grew so close as brothers they would only respond to business mail addressed to "The Dodge Brothers" but not to each individually. In 1887, Horace invented a ball bearing that could be used in bicycles. This produced enough income to allow them to open their own machine shop. In 1902, Ransom E. Olds approached the Dodge Brothers to produce auto parts for him. That in turn led to a connection with Henry Ford, and by 1910 the Dodges were so successful they began to consider building their own cars. Their relatively small early machine shops were inadequate for what they had planned, so in June 1910, they bought a parcel of land at the southeast corner of the Village of Hamtramck on the outskirts of Detroit. By November 1910, they were producing parts, still for Henry Ford, but with the goal of making their own cars by 1914. The new factory required workers, so a call was put out for laborers. It was answered in a tremendous way. In 1910, Hamtramck had a population of 3,500. By 1920, it had exploded to 48,000, and almost all were Polish immigrants who came to work at the Dodge plant and nearly two dozen other factories that helped feed it. In the space of a decade, Hamtramck had grown from being a farming village to a major industrial town. The Dodge Brothers completely changed the character of Hamtramck, leaving an indelible stamp on the city that would outlast their factory. Dodge Main grew to be one of the largest factories in the world, employing some 45,000 people at one point. The Dodge Brothers, however, never lived to see its full success. Both brothers died in 1920. But their legacy lives on, not in their factory, which was demolished in 1981 (above right), but in the way they changed Hamtramck forever.

Banking and Brewing

Joseph Chronowski organized Auto City Brewing Company with his brother, Stanislaw, in 1910. As Prohibition approached, Joseph branched out into banking and founded Liberty State Bank in 1918. Originally located at Jos. Campau and Norwalk Streets, Liberty Bank moved down the block to a new site in 1936 where it remained for many years until it ultimately was bought by the Huntington Bank. But Joseph's initials remain in stone above his original building. He died in 1958.

"All Right"

When Edmund Tyszka arrived in America from Poland in 1907, the only English words he knew were "All right," which he had heard on the boat coming over. Even so, he became one of the people who built Hamtramck—literally. Tyszka became a banker and Realtor who was a key player in Hamtramck's building boom in the second decade of the 20th century. He's seated in car with his wife, May, and daughter, Leocadia, below. He died in 1975 at age 83.

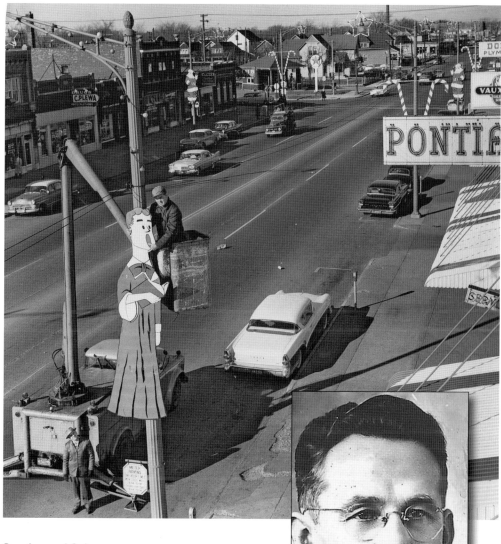

Service and Sales

Adam Ostrowski had several careers, including serving as the city's director of public works. But he is probably best known for operating Adam Motor Co., on Jos. Campau Avenue in the area once known as Automobile Row. Ostrowski sold Packards. He also was a veteran of World War I and was active in numerous veterans' organizations. In many ways, he was a typical Hamtramck auto dealer who shared space on Jos. Campau Avenue with his friendly competition. Among the many other dealers on the strip from the 1930s through the 1960s were Margolis Auto Sales, Dick Connell Chevrolet, Johnny Motor Sales, Cousin's Motor Sales, Woody Pontiac, Connell Cadillac, Edmund Motor Sales, and Krajenke Buick.

Wide Vista
Vista TV was as much a fixture on Jos. Campau as the appliances Leo Fedoruk sold inside. Like many Hamtramck stores, it wasn't unique in what it sold—a wide variety of TVs, radios, and related products—but in the service it delivered and the personal attention from the staff. Fedoruk became a familiar figure around town.

A Perfect Fit
Dave Stober opened his first clothing store on Jos. Campau Avenue in 1929, and over the years he established himself as one of the city's pre-eminent businesspeople. He also sponsored many community activities, including highlighting servicepeople during World War II in the Yank of the Week feature in the *Citizen* newspaper. (Here he is with Pvt. Ed Lekki.) Stober's store burned in 1974. He was planning to reopen it when he died of a heart attack. He was 68.

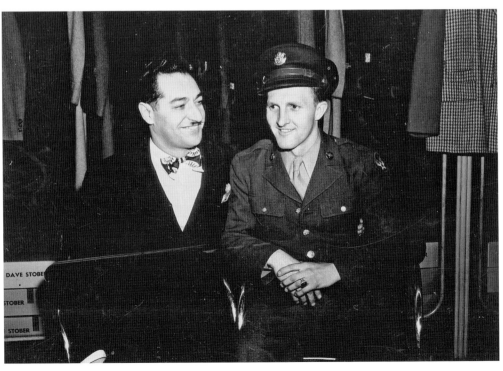

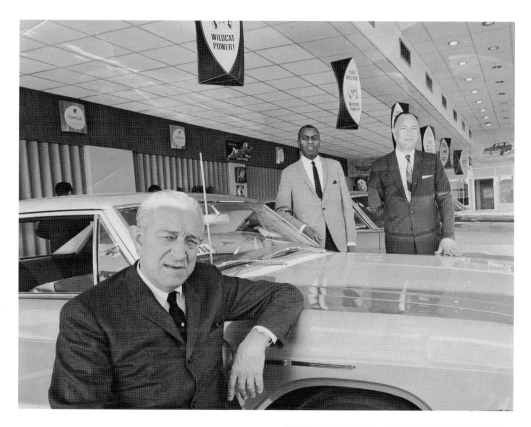

Good Deals

Stanley Krajenke is reportedly the first man to drive a car in Hamtramck. In 1913, Krajenke opened a garage and auto accessory shop, which evolved into selling Hupmobiles, and in 1922 started selling Buicks. It grew to become the world's largest Buick dealership, prospering with the motto: "Hard to spell, easy to deal with." The business was taken over by Stanley's son, Clarence, who is at front in the photo.

Hardware Heaven

In a way, Art Moss was ahead of his time. He operated Art's Hardware store on Jos. Campau Avenue from the 1940s to the 1960s, and it was legendary as the place to go for all manner of hardware. Art's Hardware store became an integral part of the shopping scene and flourished as one of the places where you could always find that one item that no one else seemed to have.

Veterans Who Cleaned Up

Walter Borucki (left) and Robert Popowski founded Veterans Supply store in the wake of World War II with the thought that no one would refuse veterans doing business. They were right. The store prospered for about 50 years selling canned goods, beer, tobacco, and other products before switching to janitorial products. It became the place to go for cleaning needs.

Feeling Good

Dr. M.W. Jabczenski began practicing chiropractic in Hamtramck in 1923. In 1936, he built his distinctive art deco–style clinic on Caniff Avenue. It was remodeled and enlarged in 1948 when additional patient rooms and a large X-ray room were added. Also that year, his son, Dr. Mitchell Jabczenski, joined the practice. After the clinic closed, the building found a new life as a Muslim mosque.

Paper Palace

Jeanette's Book Shop on Jos. Campau Avenue was a quirky Hamtramck original. It was small, had a tiny stock of material, and the service could often be curt. Owner Kleofas Napieralski dominated her tiny kingdom for 40 years and ran it with daughters Jeanette and Marie. It began as a candy store but after five years moved slightly down the street and converted to selling paper products.

A Cut Above

Norman Langowski began cutting hair when a trim cost 75 cents and a brush cut was the popular style. That was in 1955, and for 48 years after that Langowski steadily cut hair—and built a legion of faithful customers—at his barbershop on Jos. Campau Avenue. It didn't change much, really, although it took on the updated name of Norman's Barber Styling. He retired in 2003.

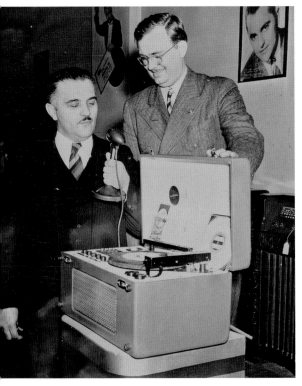

A Right Note

Henry Bejnar was not musically inclined, but he operated Bejnar's Music House for decades beginning in the 1920s. It was the place to go for musical instruments, and later, appliances. Bejnar, like many merchants of the time, was involved in many civic activities, including raising donations for the Red Cross and the Community Chest. In the photo, he's standing by Nicholas Gronkowski.

Keep It Lively

There was "never a dull moment" at Johnny Lega's bar on Jos. Campau Avenue. Lega's place typified Hamtramck's honest bar scene following Prohibition. More than a drinking establishment, it was a neighborhood gathering spot for adults to socialize in a casual atmosphere. Like many bar owners, Lega sponsored local sports teams. In the photo, Lega (center) is being presented with a trophy by Al Blum (left) and Walter Paspiech, in appreciation for his sponsorship of a bowling league.

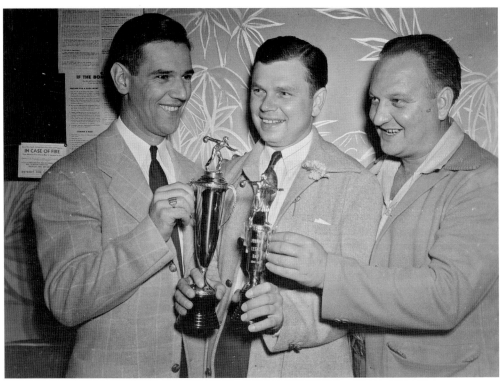

CHAPTER SIX

Notorious

Notorious barely begins to describe Hamtramck in its wild days during the Prohibition years. The city developed a reputation as a wide-open town, littered with speakeasies and bawdy houses. How many? No one knows, but in post-Prohibition years, Hamtramck had at least 200 bars operating at one time in its 2.1-square-mile area. There were probably twice that many bars when they were illegal. It was a perfect breeding ground for corruption. And corruption ruled. By 1923, Gov. Alex Grosebeck sent in the state police to take charge of law enforcement. They had a lot to deal with.

Paddy McGraw's brothel flaunted its presence. Nearly everyone was brewing gin in the bathtub, and gangsters ruled the landscape. Even Mayor Peter Jezewski was caught in the web of corruption. He was implicated when a convoy of illegal liquor was stopped as it rolled into town. Things calmed down with the end of Prohibition, but Hamtramck long sported a reputation as a wild city.

Prohibition
Barrels, beer, and illegal stills were part of the fabric of
Hamtramck for years.

"Doc Ten"

It isn't quite fair to label Dr. Rudolph Tenerowicz as "notorious." He did a lot of good in his life, often treating people for free during the Great Depression years when so many couldn't afford to pay him. He seemed to provide solid leadership during his sporadic years in office. And finally, he was a product of his times, at the tail end of Prohibition and the depths of the Depression. But Tenerowicz also seemed to invite notoriety, igniting a nasty divorce that blazed across the front pages of the local newspapers for months. Doc Ten, as he was known, arrived in Hamtramck in January 1923, setting up his practice at 9005 Jos. Campau. He was a 1912 graduate of the Chicago College of Medicine and Surgery. He practiced medicine for a decade in Chicago before coming to Hamtramck, where he soon found that medicine wasn't enough for his ambitions. He turned to politics and by 1928 had built up a political base large enough to lift him into the mayor's seat. But by the end of his first term, Tenerowicz had been convicted in circuit court of abetting racketeers. Graft was rampant in Hamtramck at that time, and there was money to be made protecting the corrupt ones. In January 1930, Tenerowicz resigned from office and spent nine months in prison before Gov. William Comstock bowed to relentless public pressure to pardon him. Comstock, a Democrat, couldn't afford to alienate the huge voting block of Democrats in Hamtramck. When Tenerowicz arrived home from prison, he was given a new Chrysler by his loyal supporters. Tenerowicz was quickly back on the political scene and was elected mayor again in 1936. His ambitions were almost derailed, however, when he filed for divorce from his wife, from whom he had been separated for years. The divorce turned ugly and got worse when his wife charged that he had three lovers, identified in court papers as madam X, Y, and Z, and he had two "love nests" in northern Michigan. But Tenerowicz survived the scandal and went on to better things, being elected to Congress in 1939. His political demise came in 1946 when he switched from the Democratic to Republican Party. Hamtramckans could tolerate corruption and philandering, but not Republicans. Thereafter he lived a quiet life. He died on August 31, 1963.

Badder Than Anyone

He was Hamtramck's baddest boy. And he was a solid citizen. Patrick J. "Paddy" McGraw may be the most colorful person in Hamtramck's history. There's no way to put it gently. Paddy McGraw achieved notoriety for running one of the largest, most successful brothels in Michigan—maybe in America. It stood at the railroad tracks on the far south side of town. The rail line made it easy for customers to drop in from as far away as Port Huron and Toledo, Ohio. And inside the two-story building they would join an assembly line procession of men who would climb up the stairs in turn. The building, crumbling, stood until 1981 when it was demolished to make room for the General Motors Poletown plant. With it went the story of a truly remarkable character. Had he been just another Prohibition scofflaw, he would be long forgotten. But McGraw had style. Sure, the girls flaunted their charms at his house, where the liquor flowed despite Prohibition. But as the *Citizen*

newspaper said on the 10th anniversary of his death: "The tough McGraw was also a lover of animals. If a stray cat wandered onto his porch on some winter day, it was just like Paddy to give him a home." His generosity extended far beyond animals. He was a founder of the Old Newsboys Association, which sold newspapers to raise money to buy Christmas gifts including toys, food, and candy for needy children. McGraw also sponsored sports teams and maintained a high profile in town. The fact he was able to do so openly was a testament to just what a wide-open city Hamtramck was. Paddy McGraw's made no secret in what it offered in terms of liquor and ladies. His clientele was wide—"silk-hatted downtown business to dirty-faced, overall laborers," the *Citizen* newspaper reported in his obituary in 1936. "Old timers, who have watched Paddy's progress in Hamtramck with a sly smirk on their faces, still recall that a Saturday night at St. Aubin and Clay Avenues resembled the scene of the Democratic Convention at Philadelphia." Paddy reached his peak in 1927, but began to come under pressure from reformers. His place was raided several times by the police, and padlocked for a year by federal judge Charles C. Simmons. But it wasn't police pressure that put McGraw out of business— it was competition. When Prohibition ended, bars began to pop up all around his place. Finally, Paddy gave it all up and moved to his cottage at St. Clair, Michigan. It was there he died in 1936 after injuring himself while working on the cottage.

Less Than a Hero

During the years he lived on Evaline Street in Hamtramck, Eddie Slovik had a history of run-ins with the law before he entered the Army in World War II. But he and the Army were a poor match, and he deserted twice. After being recaptured, he was sentenced to be executed—the first man shot for desertion since the Civil War. The sentence was carried out on January 31, 1945, in France. His death still stirs controversy. His story was told in the TV movie *The Execution of Private Slovik* starring Martin Sheen. Slovik is buried in Woodmere Cemetery in Detroit.

Better Red

Mary Zuk made history in Hamtramck several times. She was the first woman elected to the city council, in 1937, largely on the strength of her popularity for leading the meat strike of 1935. The strike brought her national attention—and notoriety. Often accused of being a Communist, she never really confirmed nor denied it. Her political career was brief, however, brought to an end not by her politics but by a nasty divorce that was recounted in lurid newspaper stories.

Perpetual Trouble

In the end, it was parking meters that caused Walter Kanar's political career to expire. And that was the last chapter in a career that was dogged by controversy. Kanar made a name in politics early—by age 27 he was a state legislator. And just as quickly he was embroiled in trouble, facing charges of obtaining citizenship papers fraudulently. He had been born in 1901 in Warsaw, Poland. He beat the fraud claim, but was hit with an attempted bribery charge four years later. In 1934, he was elected to the Hamtramck city council, and was elected the city's fifth mayor in 1940. Within two years, he was forced to resign, after he was accused of taking kickbacks in awarding a contract to install parking meters on Jos. Campau Avenue. But he was never convicted of anything, and slipped out of public life. He died in 1958.

Tickets, Please

Parking has always been a problem in Hamtramck, but municipal court judge Rudolph Maras had a novel way of dealing with the numerous parking tickets that were issued. He dismissed them—if there was some cash attached to them. At least that is what the Michigan Judicial Tenure Commission said when it suspended his law license. That was in 1967. Maras was still fighting the charge in 1971 when he died at age 56.

Bernice Onisko

Some people achieve notoriety by what they do; some by what is done to them. Bernice Onisko by all accounts was a sweet 17-year-old girl who was devoted to her family. She prayed for her family often, and was on her way home from church in March 1937 when she was brutally raped and murdered in the alley near her home. That became the most notorious crime in Hamtramck's history, as the police floundered in the huge manhunt that lasted for months. Despite following up numerous leads, her killer was never found.

Communist Home

One of the most notorious newsmakers in Hamtramck wasn't a person—it was a place: The International Workers Home on Yemans Street. Built in 1919, it was the headquarters of the local Communist Party, and for decades, hundreds, if not thousands, of meetings and rallies were held there. It was the focus of FBI investigations. Long abandoned, the building was deemed unsafe and demolished in 2007.

The Law (Sort of)

Residents of Whalen Street probably have no idea their street memorializes a potentially notorious character. Barney Whalen was Hamtramck Township marshal, and served for 15 years as the chief of police for the Village of Hamtramck. It was a time when brothels, speakeasies, and gambling halls proliferated. Whalen was never indicted on any charges of collusion or corruption, but how he managed to overlook all that illegal activity in town is a question that will never be answered.

Red Power

For sheer tenacity, it would be hard to find someone as indefatigable as George Kristalsky. Through the 1930s and 1940s, he ran for office on the hopeless platform of representing the Communist Party. He actually drew 1,372 votes in the 1940 election, finishing 16th in a field of 44 running for city council. But the Communists—especially after the Soviet Union's subjugation of Poland—fell out of favor. And Kristalsky ended up running a drugstore in Detroit.

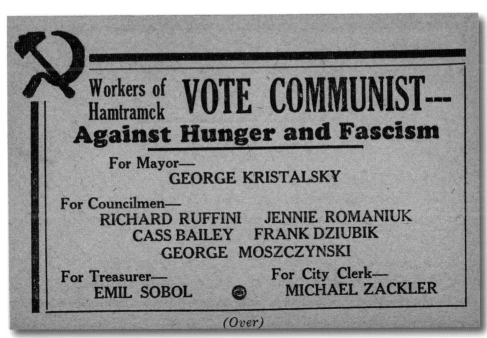

81

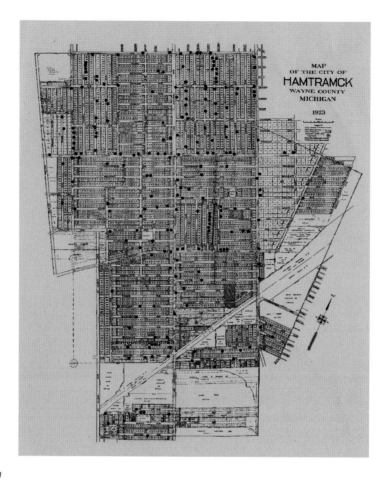

Drink Up!

In a way, it was inevitable. The temptation was just too great. When Prohibition began in 1920, Hamtramck was perfectly situated to avoid the law. Completely surrounded by Detroit, yet independent from its big city neighbor, Hamtramck became an oasis for those in search of an illegal drink. The city sort of became a giant speakeasy. No one knows how many bathtubs were being used to distill gin or how many bottles of beer were being filled in basements, but it surely was vast—and profitable. And everybody wanted to get into the act, including the local police and city officials. Speakeasies and brothels were allowed to flourish by the local authorities, who were glad to accept payment for looking the other way. The Detroit newspapers were outraged and routinely ran stories about the rampant corruption in Hamtramck. The city even achieved national notoriety, which angered local officials and honest citizens. When the police and some city officials were implicated in leading a convoy of illegal liquor into the city, the state finally stepped in. In 1923, the state police took over control of local police operations. They conducted a series of raids between December 1923 and March 1924, which is reflected in this map. Scores of places, including many private homes, were raided. The city officials responded by routinely ordering crackdowns on the local vice spots. These occurred with regularity and accomplished virtually nothing. The vice spots were generating just too much revenue to be closed. Besides, the local folks thought Prohibition was an absurd idea and they were not about to stop drinking, no matter what the law said. The situation eased greatly when Prohibition ended in 1933, but illegal stills could be found secreted around town well into the 1960s. But overall, vice faded, and while the state inserted itself into the city's operations many times over the decades to help it deal with financial crises, the state police never needed to return.

CHAPTER SEVEN

Goodness Shows

When the Polish immigrants came to Hamtramck, they brought their deep sense of religious faith with them from the old country. They weren't alone in their beliefs. The local African American residents had established their own churches as well and there was at least one synagogue in town. Religion was a cornerstone of Hamtramck. For decades, the city virtually shut down on Good Friday. At Christmas, churches were packed to standing room only capacity. And what churches they were. The immigrants routinely mortgaged their homes and gave every penny they could to the churches. As a result, Hamtramck boasts some magnificent houses of worship, like St. Florian, which won the American Architect's Award in 1929 for its beautiful design.

These days, the churches have been joined by mosques that serve the growing Muslim population. And there is space for everyone—including Catholic churches, an Evangelical Christian church, Baptist churches, a Zen Buddhist center, a Hindu temple, a Jehovah's Witness Hall, and the mosques.

Services and Churches
Deep faith also was a hallmark of Hamtramck, shown
not only by the services the residents have attended but
also in the magnificent churches they built.

For the People
Rev. Joseph Jordan accepted the challenge of leading Corinthian Baptist Church in 1973. Corinthian Baptist was founded in 1918 and is one of the most venerable churches in Hamtramck. Outside its walls, Reverend Jordan is a member of numerous civic and professional organizations, including serving as president of Todd-Phillips Children's Home and on the executive committee of the Greater Detroit Area Health Council. He and his wife, Bobbie Drake Jordan, have two children, Kimberly and Sandra.

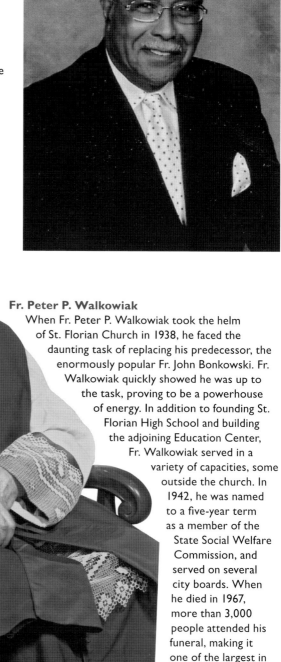

Fr. Peter P. Walkowiak
When Fr. Peter P. Walkowiak took the helm of St. Florian Church in 1938, he faced the daunting task of replacing his predecessor, the enormously popular Fr. John Bonkowski. Fr. Walkowiak quickly showed he was up to the task, proving to be a powerhouse of energy. In addition to founding St. Florian High School and building the adjoining Education Center, Fr. Walkowiak served in a variety of capacities, some outside the church. In 1942, he was named to a five-year term as a member of the State Social Welfare Commission, and served on several city boards. When he died in 1967, more than 3,000 people attended his funeral, making it one of the largest in Hamtramck's history.

The Papal Presence

When Karol Wojtyla was named as Pope John Paul II in 1978, Hamtramck went into ecstasy. It wasn't just that he was a Polish pope—although that would have been reason enough in the primarily Polish town—he also had a connection to Hamtramck. His cousin, John Wojtylo, had been a Hamtramck city councilman in the 1940s and 1950s. And Cardinal Karol Wojtyla had visited Hamtramck, saying Mass at St. Florian Church and visiting St. Ladislaus and Our Lady Queen of Apostles churches. Pope John Paul II further cemented his relationship with Hamtramck on September 19, 1987, when he came to the city to deliver an address from a massive pavilion built on Jos. Campau Avenue near St. Florian.

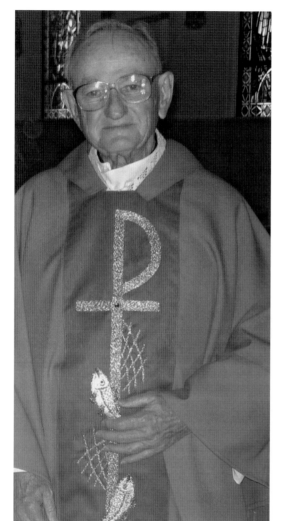

A Man of Devotion

For Rev. Edward Sobolewski, Holy Cross Polish National Catholic Church was more than his parish: It was his home. For more than 40 years beginning in 1956, he led the small parish with great devotion, matched only by the love he felt for his family. On his death at age 83 in 2008, his daughters wrote a loving memorial to him commemorating his devotion.

A Man of Character

Fr. Ted Ozog personified the dynamic character that was typical of the pastors of St. Florian Parish. He had a scholarly educational background, having served as rector of Sacred Heart Seminary College before he came to St. Florian in 1978. He could appear gruff and act tough, but he also quietly donated clothes to the needy and paid medical bills of parishioners who couldn't, among many other charitable acts. He died in 1994 from complications of AIDS, which he acquired from a blood transfusion.

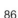

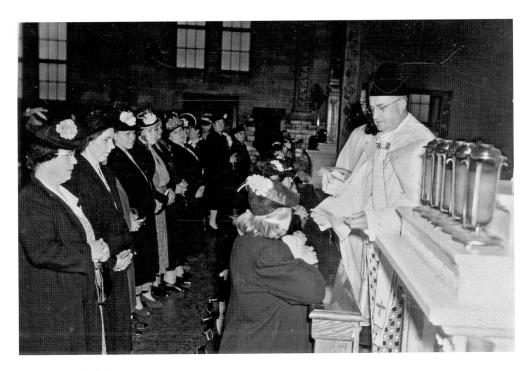

Building a Parish

For 36 years, Fr. Arthur Majewski led St. Ladislaus Parish. That's a remarkable achievement for its longevity alone, but he accomplished much more. Since assuming pastorship in 1922, he set up two temporary churches, oversaw the construction of a permanent church building, and established an elementary and high school and a convent. He died in 1958 at St. Ladislaus.

"Fr. Ted"

For 23 years, Fr. Ted Blaszczyk was pastor of Our Lady Queen of Apostles Parish. During that period, he became a beloved figure across the community. Fr. Blaszczyk passed up a career in professional baseball to become a priest, and served at Q of A from 1970 to 1993. A high point of his career was coordinating Pope John Paul II's visit to Hamtramck in 1987. Fr. Blaszczyk died in 2008 at age 80.

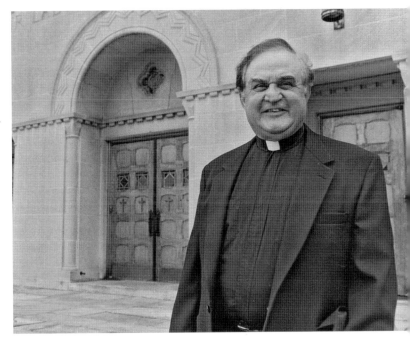

87

The Nuns' Story

They were often stern-looking forms, with only their faces visible. But they were vital to the operations of the city's Catholic churches and schools. Most nuns who taught in Hamtramck were of the Felician order. They could be rigid as rulers, and as sweet as flowers. But few who were taught by them have ever forgotten the experience. These three nuns, whose names were not recorded, are typical.

Sisters in Charge

St. Francis Hospital was built by the city in 1927 to meet the needs of the growing population. Within a few years, however, it became evident that the city was not equipped to operate a hospital, so its functions were turned over to the Sisters of St. Francis (who are represented in the photo). Aging and inadequate, the hospital closed in 1969 and was converted for use as city hall. But the front hallway niche where the statue of St. Francis stood still remains.

CHAPTER EIGHT

Notable Citizens

You didn't have to be a politician to make a difference in Hamtramck. Many people accomplished much through their grassroots efforts. In his unassuming way Leo Kirpluk, a bakery retiree, nudged the city council to take action on neighborhood improvements. Wanda Kondrat was the consummate event organizer. And Joe Kargol helped shape the city as well as keep residents informed on the pages of the *Citizen* newspaper.

And there were many others. Some barely attracted attention, yet they played a role in the vast and colorful character of the city. All deserve to be remembered.

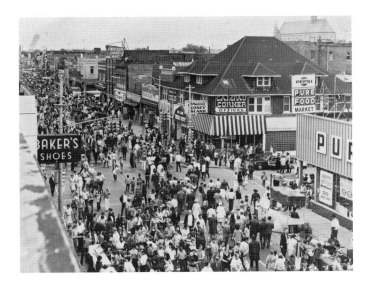

A Human Tapestry
So many people, so many stories. All have made an impact on
Hamtramck, but some stand out.

Godfather of the Bomb

When two atomic bombs exploded, helping bring World War II to an end, virtually no one in Hamtramck knew that one of their own played a big role in those big bangs. Emil Konopinski was the president of the Hamtramck High School class of 1929 and editor of the *Cosmos* school newspaper. But while he showed talent, he was destined to work on the assembly line at the Dodge Main auto factory to help support his family. That's when Hamtramck High School principal E.M. Conklin stepped in. He approached the Hamtramck Rotary Club, which provided Konopinski with a full scholarship to the University of Michigan. He quickly distinguished himself in the field of physics and won a two-year fellowship to Cornell University. In 1938, Konopinski was asked to take over the physics research laboratory at Indiana University, where he continued to distinguish himself. That led Konopinski to work with Enrico Fermi to develop the first nuclear reactor at the University of Chicago. With the outbreak of World War II, Konopinski was selected to be among an elite group of six theoretical physicists called to Berkeley, California, to consider the development of the atomic bomb. They had been selected to participate in the program by Karl Taylor Compton, president of the Massachusetts Institute of Technology, acting at the instruction of Pres. Franklin Roosevelt. The scientists took up residence at the Los Alamos National Laboratory to begin work on the bomb. Konopinski was specifically given the task of determining if exploding the bomb would ignite the earth's atmosphere and destroy the world—a rather serious question. Konopinski was present at the first testing of the atomic bomb in 1945, which he described as the most awe-inspiring sight he had ever seen. A decade later Edward Teller, considered the father of the atomic bomb, recalled the valuable role that Konopinski played in the process and paid tribute to him. From 1946 to 1968, Konopinski served as a consultant to the Atomic Energy Commission. He died in 1990 at age 78. In the photo, Dr. Konopinski is third from left with associates William Penney, Beatrice Langer, and Lawrence Langer. (Courtesy of the Los Alamos National Laboratory.)

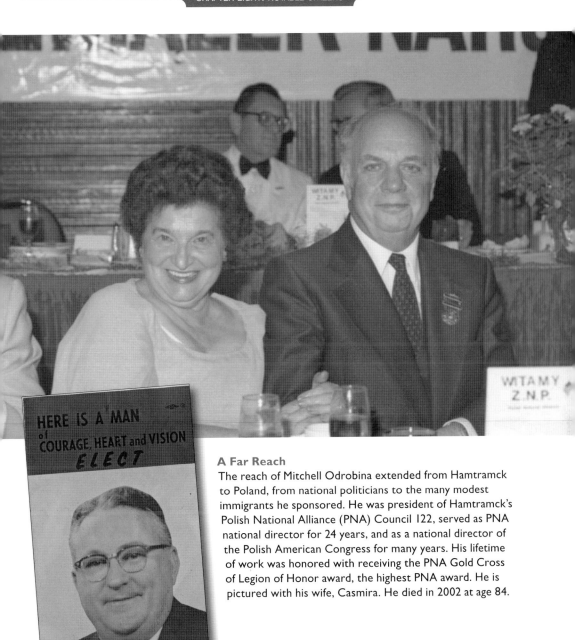

WITAMY
Z.N.P.

HERE IS A MAN
of COURAGE, HEART and VISION
ELECT

Number 14 On Your Ballot

JOHN J.
KOZAREN
Congressman

A Far Reach

The reach of Mitchell Odrobina extended from Hamtramck to Poland, from national politicians to the many modest immigrants he sponsored. He was president of Hamtramck's Polish National Alliance (PNA) Council 122, served as PNA national director for 24 years, and as a national director of the Polish American Congress for many years. His lifetime of work was honored with receiving the PNA Gold Cross of Legion of Honor award, the highest PNA award. He is pictured with his wife, Casmira. He died in 2002 at age 84.

A Force

John Kozaren established himself as a political force not just in Hamtramck but across the area. In 1943, he was appointed Wayne County treasurer, the first Hamtramckan ever to serve in county government. He also was named chairman of the First Congressional District Democrats, and was manager of the State Liquor Control Commission's Detroit area. He was the father of later mayor Robert Kozaren.

RAYMOND ZUSSMAN
Second Lieutenant
U.S. Army, 756th Tank Battalion

MEDAL OF
POSTH
Noroy
12 Se

A True Hero

On September 12, 1944, Lt. Raymond Zussman was in command of two tanks operating near the village of Noroy le Bourg in France. Leading the tanks with just a rifle, he went on alone several times, and single-handedly captured 92 enemy soldiers while 18 were killed as he braved enemy gunfire and grenade attacks. Shortly after that battle, Lieutenant Zussman was killed in action. For his bravery, he was awarded the Congressional Medal of Honor, the only Hamtramckan to receive that high award.

US·POSTAGE 3¢
HONORING GEN. GEORGE S. PATTON, JR.
AND THE ARMORED FORCES OF THE U.S. ARMY

Joseph W. Stilwell
USA 10
General, U.S. Army

USA 33
Omar N. Bradley

GEN PATTON MEMORIAL AWARD HONORS

General Walton H. Walker
US ARMY

US ARMY COMMANDER
DESERT TRAINING CENTER
1942-1944
VETERANS DAY STATION
NOVEMBER 9, 2002
CHIRIACO SUMMIT, CA 92201

NOR RECIPIENT
US AWARD
urg, France
ber 1944

93

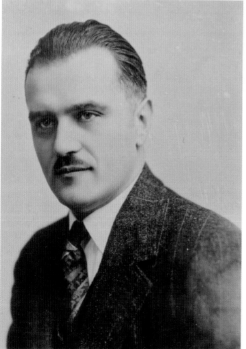

Rau's House

What can you say about Leo Rau? Well, he wore a goatee and mustache in the 1940s when virtually no one else did. And he might sport a top hat. And there was only one other bar in Hamtramck that could compare with his House of Rau, and it was appropriately called The Nut House. The House of Rau was noted for the hundreds of items of all sorts that decorated the interior. Rau—minus the beard and with mustache trimmed—ran for common council. He lost.

Longtime Judge

For more than 20 years, Nicholas Gronkowski served as justice of the peace in Hamtramck, starting in 1934. Like so many Hamtramck officials, he was born in Poland. Educated in America, Gronkowski practiced law in Massachusetts before coming to Hamtramck in 1927. He was noted for being fair and sympathetic. He died on January 27, 1955, of a heart attack.

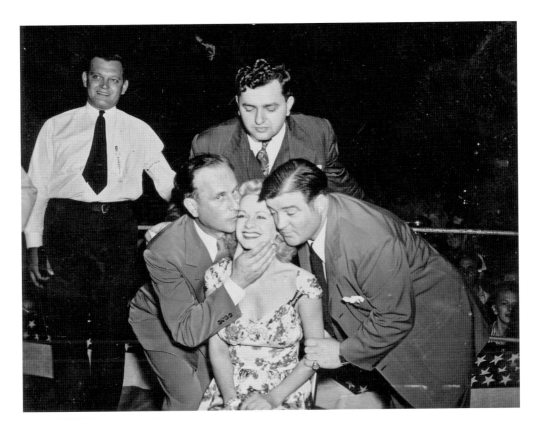

Meet the Press

For years it was said that the people of Hamtramck read the *Citizen* newspaper like the Bible. The people certainly did take it seriously, as it helped shape city policy and relate the stories of its residents for more than 70 years. The *Citizen* wasn't the first or only newspaper in Hamtramck. Through the decades, there were many newspapers but none had the reach of the *Citizen*. That was primarily because of Joseph Kargol, and later, his wife, Frances. The *Citizen* was founded in 1934 and faced direct competition from the *New Deal* newspaper. Both were weeklies that focused exclusively on the news of the town and both were fearless in covering the raucous political scene. A journalism graduate of Wayne State University, Joe Kargol started his career as sportswriter and then editor of the *New Deal*, then in October 1937, joined the staff of the *Citizen* as city editor. The *New Deal* folded in 1939 when its staff organized the *Plain Dealer* newspaper, which stayed in business until 1953. Kargol became part owner of the *Citizen* with William A. Blackport in 1944 and bought him out in 1947. From then on, the *Citizen* was to a great degree a reflection of Joe Kargol. It was a feisty newspaper that understood all the intricacies of Hamtramck's Byzantine politics. And it was fearless. The *Citizen* never bowed to political pressure and always stayed true to its mission of being a community newspaper. As such, it covered intimately all the happenings of Hamtramck, big and small. When presidents visited the city, the *Citizen* was there. And when Sylvia Wipy and Anthony Furman were married at St. Ladislaus Church on May 16, 1942, the *Citizen* carried the announcement. All of Hamtramck was there, momentous and minor. The *Citizen* made its presence felt in other ways as well. Kargol helped organize Abbott and Costello's war bond drive effort in August 1942. That's him with the two comedians and Ethel Shepherd, a local singer. The *Citizen* lasted until 2009 when it fell victim to the changing times that devastated the newspaper industry as a whole. But within a few weeks of its demise, it was essentially reborn as the *Review* newspaper. As for Joe Kargol, he died in 1974 at age 59. After his death, the paper was run for many years by Frances, and then their daughter, Karen. But it never lost its focus on Hamtramck.

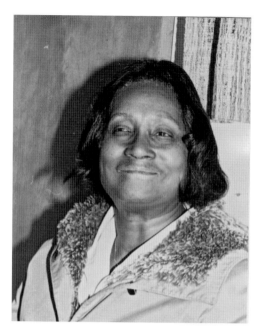

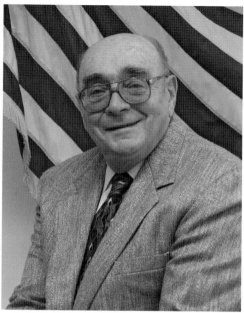

Giving So Much

Amanda Dumas gave so much to the community that it can only be touched on here. She was known as a "Walking Angel" for her efforts to help numerous charities. She made sure that seniors received Meals on Wheels, and often gave lunch money to needy students at Hamtramck High School, where she worked. "She was a great inspiration," said Rev. Joseph Jordan, of Corinthian Baptist Church. She died in 2001 at age 80.

Music Man

After surviving a harrowing experience in a Nazi concentration camp, Walter Budweil came to America with his wife and daughter. In 1950, he became organist and music director at Our Lady Queen of Apostles Church, a position he has held since then. He also developed the parish choir, which performed for Pope John Paul II when he visited Hamtramck in 1987. Ever energetic, Budweil was still active at age 90.

Fighting for Justice

James Sephers was unflappable in his determination to make Hamtramck a better place. For years, he petitioned the city government to right perceived wrongs and take action against injustice. Often he stood alone, but he never backed down. He died in 1998 at age 96, but his legacy is remembered still today.

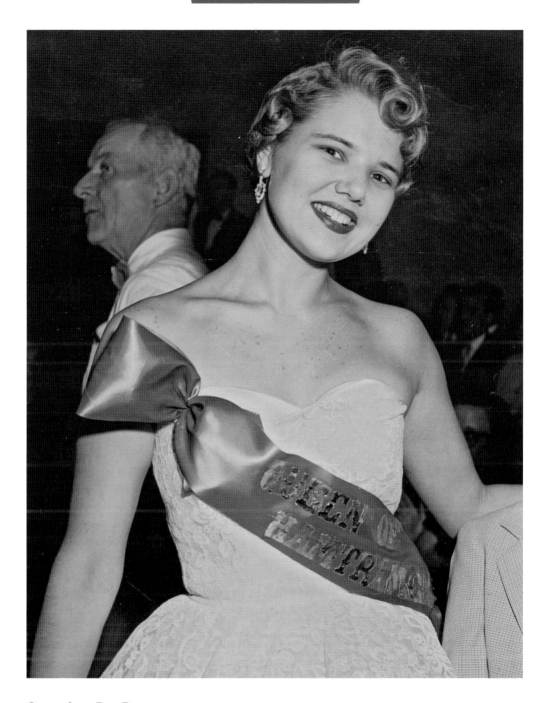

Queen for a Few Days

For a few brief days, Lee Barecki was the queen of Hamtramck—and she met Roy Rogers. Barecki was named queen for Dodge Days, a weeklong citywide festival and promotion sponsored by the Chrysler Corporation in November 1954 to introduce the 1955 models. Roy Rogers was the special guest. Barecki, then 21, was chosen for her "charm and beauty," and received a host of gifts including an evening gown and wristwatch. In her day job, she was a clerk at the Dodge Main factory.

Political Powerhouse

Theophilus T. Dysarz was a political force in Hamtramck's early city days. Like his compatriot, Mayor Peter Jezewski, Dysarz was a doctor from Buffalo, New York. He came to Hamtramck in 1914 and opened a practice on Jos. Campau. In 1917, he built an impressive two-story brick building at the corner of Jos. Campau and Caniff Streets. His initials still adorn the building. By the time Hamtramck became a city in 1922, Dysarz was the town's health commissioner. He aligned himself with Jezewski, and although the two had a falling out, they apparently reconciled by 1930 when Jezewski convinced Dysarz to run against Rudolph Tenerowicz for mayor. Dysarz lost. He retired in 1946 and moved to Florida. He died in 1973 at age 84. Dysarz also served on the Hamtramck School Board from 1934 to 1937 and was a member of numerous social and professional organizations.

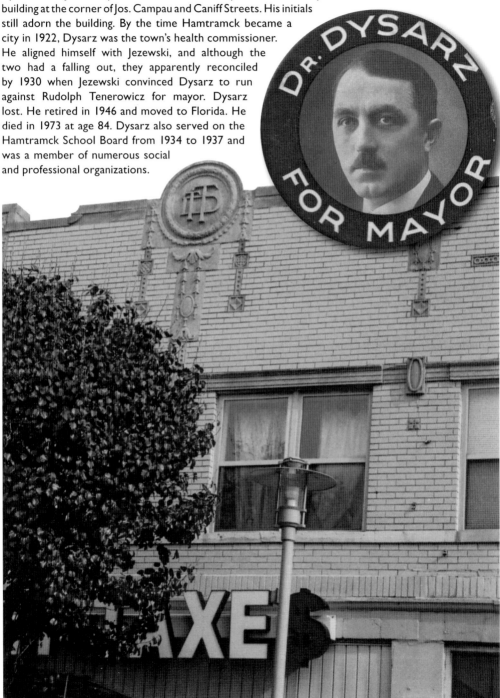

First Casualty
Nearly 200 Hamtramckans were killed in World War II. Cpl. John Targosz was the first. He died on September 12, 1942, while fighting in the Solomon Islands. Targosz, a Hamtramck High School graduate, had enlisted in the Marines in 1940, before the bombing of Pearl Harbor. His name, along with all the other Hamtramckans who made the ultimate sacrifice, is engraved on the monument at Veterans Memorial Park. (Courtesy of the *Review*.)

So Much Done
A list of Yvonne Myrick's accomplishments would fill a book of its own. In 2001, she became the first African American woman elected to the Hamtramck School Board and the first African American to hold elected post in the city since 1924. She worked for the city and was president of city employees Local 666, and has been extremely active in the community, including serving on numerous boards of several organizations. She has won many awards for her diverse activities.

Long-Term Service

Chester Reese billed himself as a "product of Fr. Flanagan's Boystown," when he ran for mayor in 1975. It didn't help his election bid, as he lost. But Reese did manage to serve more than 30 years on the Hamtramck School Board before retiring in 1990. He also is remembered for his years as an active union member, including serving as president of a city workers' union local.

Extraordinary Artist

From King Arthur to the king of Poland, artist and former Detroit Denby High School teacher Dennis Orlowski has painted a vast array of people, places, and things in large-scale murals. Orlowski's works are featured in buildings throughout Michigan. One of his most impressive works is the sprawling History of Hamtramck mural at the People's Community Service building on Jos. Campau Avenue.

Devoted
Ida Perry lived a long life—she died at age 98 in 2003—that was characterized by her devotion to the community. She was on the board of directors of People's Community Service, a member of the NAACP, and a founder of the Swankies, a pioneering African American social club. She also was a member of St. Peter A.M.E. Zion Church for over 50 years and served on the church's board of directors.

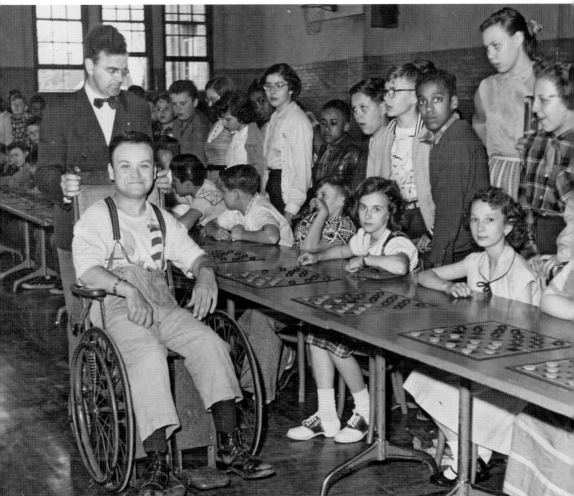

The Champ
Richard Gish was confined to a wheelchair for his whole life, the victim of cerebral palsy. But he never let that slow him down. He learned to play checkers and proclaimed himself Hamtramck's checker champion. No one was inclined to argue with him. He was a popular figure at schools and recreation department events, and was one of Hamtramck's truly colorful characters.

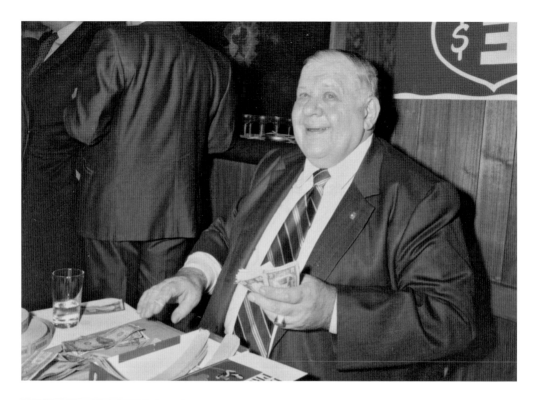

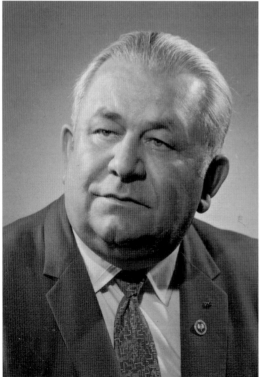

Years of Service

Stanley Wojcik was a fixture in Hamtramck for decades. He entered the public arena in 1939 when he was appointed to the city's first Housing Commission. He also was associated with the Hamtramck Chamber of Commerce and Rotary Club. In 1968, he was named district governor of Rotary International's District 640, only the third Hamtramckan to hold that position with Rotary.

PNA President

Alfred Ulman was elected president of Polish National Alliance Council No. 122 in Hamtramck in 1945. By then the PNA was a powerful political and social organization, and engaged in a variety of charitable activities, including helping survivors from European concentration camps settle here. The Ulman family was also well known through the travel agency it operated in the city.

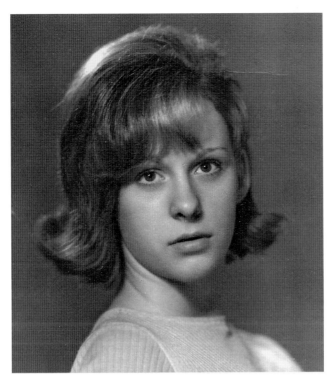

Miss 16

"It doesn't seem real," Hattie Lukasik said, as she was crowned Miss 16 of Detroit in 1967. But this Miss Detroit was from Hamtramck and a junior at Hamtramck High School. She took the title in a competition sponsored by the *Hy Lit Show* TV show and *16 Magazine*. Her prizes included a TV set, wristwatch, and a record player, which she still has.

The Perfect Pair

Wanda and Edward Kondrat were an ideal Hamtramck couple. Both were active in the city for years. When it came to hosting special events, Wanda had no equal. She was one of the chief organizers of the popular Hamtramck Labor Day Festival and for 25 years she chaired the St. Florian Strawberry Festival. She also was in charge of the city's 50th anniversary banquet in 1972, among many other activities. She was married to longtime city councilman and treasurer Edward Kondrat. He served on the council from 1958 to 1966 and as treasurer from 1974 to 1979.

A Different View

I.M. Kopkowski knew Hamtramck probably better than anyone—at least underground. As the city engineer in the 1940s, he was responsible for maintaining the infrastructure and monitoring construction projects. He even dabbled in politics, a little, and not with much success. But despite his interests below ground, he was a high-profile figure for years, active in different aspects of the city.

Dedicated to the Neighborhood

Although he never held public office, Leo Kirpluk played a great role in preserving Hamtramck through his grassroots community activities. He was active in the Hamtramck Block Club Association and constantly sought to improve the community, whether fighting to have a blighted house torn down or serving as the city's sometimes official, sometimes unofficial, photographer. He never lost his enthusiasm and love for Hamtramck. He remained active until his death, at age 88, in 2007.

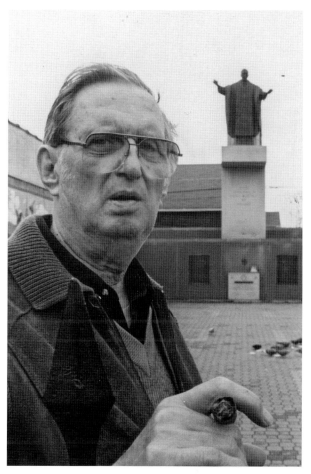

Papal Artist

When Polish Pope Karol Wojtyla was elected in 1978, predominantly Polish Hamtramck wanted to commemorate the event. So Bruno Nowicki was called upon to design a fitting monument. He did, and it still stands at the corner of Belmont and Jos. Campau Streets. A feud erupted when the city failed to pay Nowicki, but ultimately he donated the monument to the city. He died in 2008 at age 100.

Henry Kozak

For a time, it seemed like Henry Kozak was always running for some office or another. And he did make his mark in politics, as well as business. While Kozak could never defeat his often rival, Mayor Albert Zak, he did serve on the common council from 1950 to 1957. And he served on the Detroit Board of Water Commissioners and Wayne County Civil Service Commission. He also made a mark for his beer and wine distributorship and with Kozak Realty company. He died in 2001 at age 84.

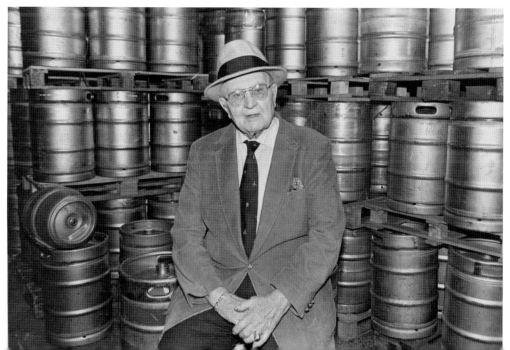

Rites of Passage

Leo Miller was one of the leading funeral directors in Hamtramck. Funeral homes, which were usually located next to churches, were prominent features in the city. The Miller, Krot, L.L. Orlikowsk, Skupny, Strickland, Jurkewicz and Wilk, Buhay Chapel, Kaczorowski, and Frontczak funeral homes have filled an important need in the community.

Imaging Hamtramck

As Hamtramck's videographer, Greg Kirchner has videotaped all types of events ranging from political forums to Memorial Day services. He has created a vast tapestry of Hamtramck. Married to library director Tamara Sochacka, he also has provided invaluable assistance to the library in a wide array of ways ranging from helping stage programs to doing maintenance. He also operates his own import business.

"The Black Untouchable"

Arthur Dillard built his reputation as "The Black Untouchable" with the Hamtramck Police Department for his outstanding police work at a time when Hamtramck was establishing its reputation as a wide-open city. Dillard joined the department in 1920 and became the city's first African American detective. He had a long, remarkable career and died in 1996 at age 101.

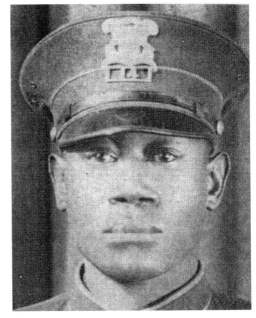

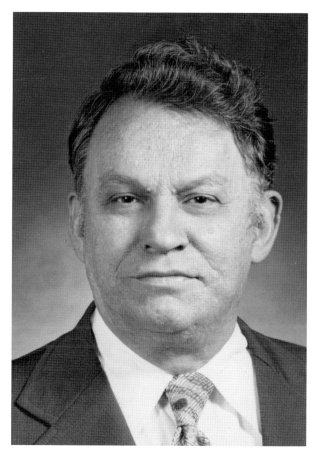

Memories

Arthur J. Majewski grew up in Hamtramck, like tens of thousands of other people. But he preserved his memories in a priceless little book called *When Hamtramck and I Were Young*. It wouldn't win a Pulitzer Prize for style, as it was broken down into numbered short passages. But in a personal way it captured all the nuances of growing up in the gritty, unique city that was Hamtramck.

Chroniclers

The Pieronek family chronicled the story of Hamtramck for nearly 80 years. Thousands of Hamtramck people and places were captured on film by the family of photographers, who opened their studio on Jos. Campau in 1925. Paul Pieronek founded the photo dynasty, which was carried on by his children. The studio closed in 2003 and now is the site of the Piast Institute.

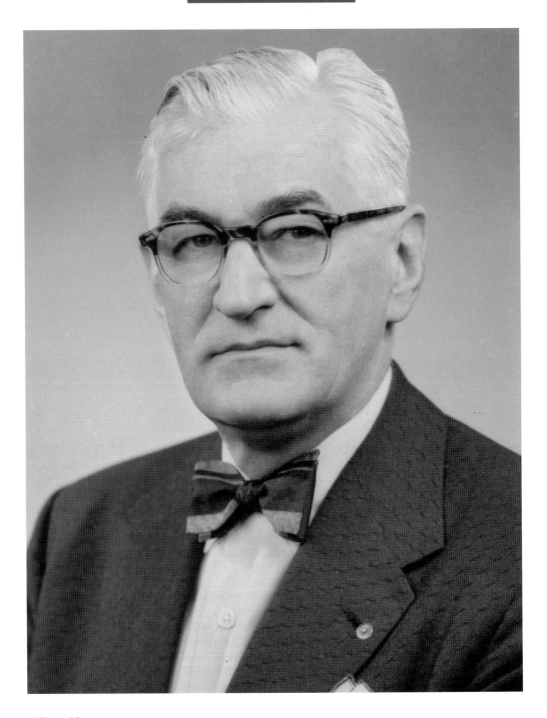

A Busy Man
Cass Piotrowski wore many hats. In the 1940s and 1950s, he was president of the Hamtramck Rotary Club, the Hamtramck Recreation Commission, and director of Liberty State Bank. With the Rotary, Piotrowski was the first person of Polish descent to head the area district. But he is probably best known for his association with the Piotrowski and Lemke insurance agency and law firm.

CHAPTER NINE

Group Effort

Not only individuals had an impact on Hamtramck. Organizations, which after all are groups of individuals, made their mark too, and in some extraordinary ways. It started with the Hamtramck Indians, the first social group to form in Hamtramck, and dating to the pre-village days. The Polish National Alliance also had a major presence in town. Many Hamtramckans were members, and the PNA helped Polish immigrants settle in the community.

But no group equalled the presence that Tau Beta had. Founded by four teenage girls, Tau Beta grew to become one of the most significant social organizations in the state. Its reach extended into the homes of Hamtramckans, at the same time providing a host of services at its community houses.

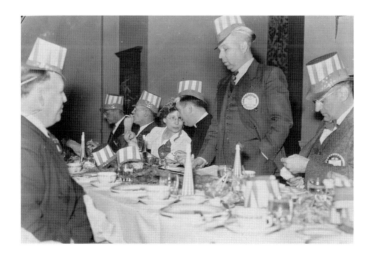

Rotary Club Christmas
Good thoughts, good acts, and good fun—like this Rotary Club Christmas party in 1942—are reflected in the many civic organizations the city has hosted.

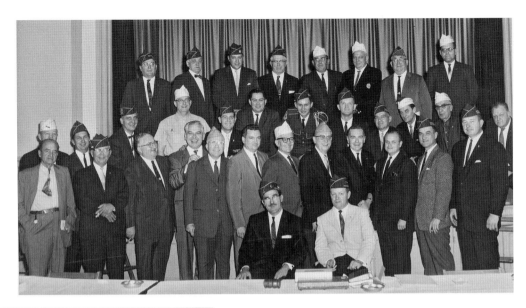

Friendship and Service

Formed in 1920 with Post No. 1, the Polish Legion of American Veterans (PLAV) aimed to foster camaraderie among veterans of Polish descent. Ultimately, it would expand services to help veterans in a wide variety of ways including job searches and obtaining service bonuses from the government. By 1930, there were hundreds of PLAV posts across the country and many remain today.

Whooping It Up

While it isn't quite clear how the Hamtramck Indians got their name, there is no doubt about the many charitable deeds they performed. Formed in 1899 by a group of local saloonkeepers and one grocer known as "The Immortal Sixteen," the Indians supposedly were christened such for their rowdy behavior. But they sponsored many charities, including providing Christmas baskets to the poor. The Indians were Hamtramck's first social organization and remained active until the 1970s.

Band of Brothers (BELOW RIGHT)

The Hamtramck Allied Veterans Council (HAVC) was formed in 1943 to bring together all the various veterans' groups in town "whereby they may lay the foundation for the permanent preservation of good government," according to their charter. The HAVC sponsored many activities through the years, including the annual Memorial Day parades. The HAVC also spearheaded the move of Colonel Hamtramck's grave from Detroit to Hamtramck in 1962. At far right is Mayor Albert Zak with mayor-to-be William Kozerski.

Goodfellows, Indeed

Patrick "Paddy" McGraw was one of Hamtramck's most notorious figures (see chapter 6), but he was also civic minded. He led a movement to establish the Hamtramck Goodfellows in the late 1920s. Since then police officers, firefighters, city officials, and a host of volunteers have come together each year at Christmas to sell newspapers to provide Christmas gifts to the needy. Even in the worst of times in the city, the Goodfellows have managed to raise money for those in need. This group photo dates from the 1950s.

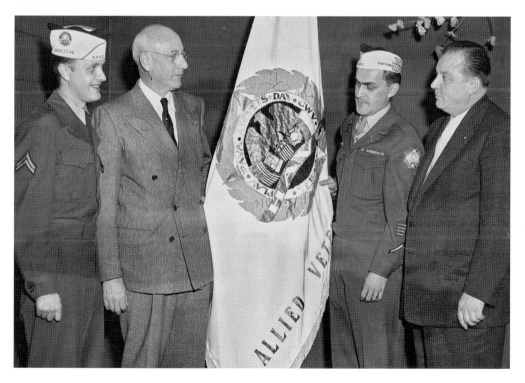

Tau Beta

Tau Beta was founded in 1901 by four 15-year-old Detroit girls. Initially, they just wanted to have fun, but decided to adopt a charitable cause to give them a sense of purpose. They linked up with the Visiting Nurse Association, which brought them to the newly burgeoning Village of Hamtramck. At that time, Hamtramck was growing wildly, thanks to the Polish immigrants moving into town to work at the new Dodge Main factory. There was a desperate need for social services, so when Tau Beta opened its "house with the light" on Hanley Street, it soon became a fixture. Over the years, Tau Beta added services and built a large community center across from its original rented house. The Hamtramck Public Library originated at Tau Beta. Amateur theater troupes formed there and critically needed medical, legal, and social services were offered. Tau Beta even created the first playground in the village. The organization also played a critical role in "Americanizing" the immigrants. Many prominent Detroiters lent their support to Tau Beta. Tau Beta left Hamtramck in 1958 after determining that it could not offer any services that the established city could not. Today Tau Beta is based in Grosse Pointe and continues to raise funds for charitable causes.

Polish Concerns

Polish National Alliance Council No. 122 was founded in 1918 and grew to be the largest Polish organization in the state. It was established with two goals: to help Polish immigrants settle in the community here and to help Poland with its struggles for independence. Over the years, it succeeded on both fronts. In 1951, the PNA Council 122 dedicated its headquarters on Conant Avenue. It is still in use.

Service to Others

The Hamtramck Rotary Club was organized on December 14, 1923, and chartered on March 29, 1924, with school superintendent Maurice Keyworth as its first president. Through the decades, the Rotary Club made significant contributions to the community in many ways, such as awarding scholarships, including honoring Hamtramck High School valedictorian Olga Tyro in 1942. With her are Rotarians Julius Lesinski (left) and Dr. Louis Goldberg.

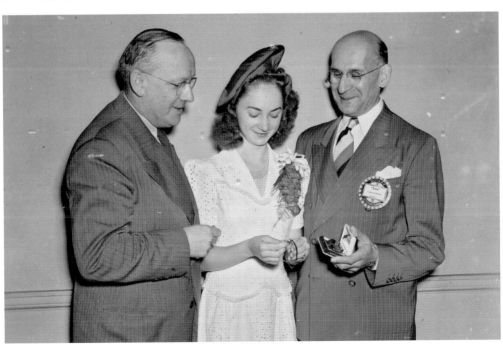

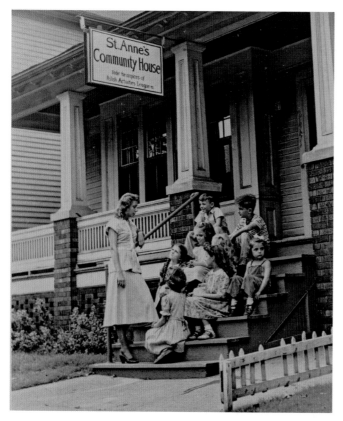

The Other House

Generally overshadowed by its big neighbor, the Tau Beta Community House, St. Anne's Community House provided its own variety of services aimed for the immigrant population. Founded in 1921 at 2441 Andrus Street by the Polish Activities League, St. Anne's conducted many programs for children and adults, like a dressmaking class for girls, athletic activities for boys, and social clubs for men and women along with naturalization and English lessons. Long closed, the building is now a private residence.

Golden

Mrs. Josephine Skopowska (second from left) was instrumental in establishing the Blue and Gold Star Mothers, Chapter 95, in 1942. The group was funded to help support the husbands and sons in the service in World War II and the mothers and wives here at home. With her are (from left) Mrs. L. Polkowski, Fr. Kiley, Mary MacDonald, and Betty Eldemayer. Skopowska was president of the group for decades.

A Friend
Hamtramck was hit especially hard by the Great Depression. Seeing the need here, American Baptist missionary Minnie Shephard drew support from the Detroit Mission Society to found Friendship House in 1929. It began offering educational classes for the immigrants and programs to the needy including preschool and parenting classes. Its motto has been "A Friend to All."

Grand Knights
The Hamtramck council of the Knights of Columbus was formed on November 13, 1929, in the wake of the start of the Great Depression. On that day, a group of men met with Fr. Anthony Majewski of St. Ladislaus Parish, who suggested they join the Knights of Columbus, a national charitable organization, which had been founded nearly 50 years earlier in Connecticut. The council encompassed men from St. Ladislaus, St. Florian, and Our Lady Queen of Apostles Parishes. In 1958, they built a modern hall on Conant Avenue.

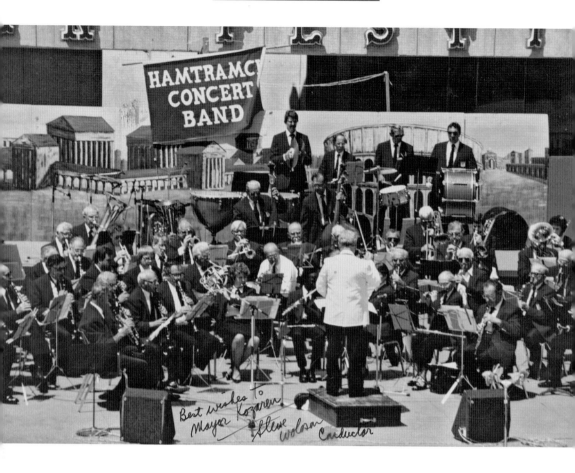

Best wishes to Mayor Kozaren, Steve Wolosin Conductor

The Sounds of Music

Music has long been a part of the fabric of Hamtramck. Children often attended music classes and many houses had pianos or other musical instruments. The first musical organization in the city was the Hamtramck Philharmonic Orchestra, formed in 1922 by Frank Grabowski. Grabowski was born in Poland and had played violin with the Hungarian National Opera Orchestra, where he later served as conductor. By 1915, he had come to America, first settling in Ohio before moving north to Hamtramck. The orchestra had eight original members. Within two years, it boasted 32 members and ultimately would grow to 60 musicians who practiced regularly and performed on Sundays at the Martha Washington Theatre. The movie theater was deemed the only suitable venue for an orchestra at the time. Later, the orchestra played at veterans' halls around Detroit and then at Lansing, Toledo, Flint, Jackson, and other places across the area. Grabowski died in 1968, but the orchestra continued to play for many years. The philharmonic orchestra wasn't the only musical organization to form in Hamtramck. In 1956, Walter P. Truszkowski created the Hamtramck Accordiana, operating out of Carlow's Music Center on Caniff Street. Within three years, members of the Accordiana orchestra had won 12 national solo awards and 176 national individual prizes. The Hamtramck Concert Band also drew many local musicians to perform at venues across the area. Hamtramck musicians also played for Pope John Paul II on the gigantic pavilion built for him when he visited the city in 1987. The musical groups served several functions. They provided venues for talented local musicians who acted as ambassadors for the city. They also were a unifying factor. In later years, many of the performers were former residents who maintained a contact with the old hometown through their performing together. And finally, they delighted everyone with their beautiful sounds.

Metropolitan Spirit Club

Formed in 1919, the Metropolitan Spirit Club was an alliance of mailmen, firefighters, and police officers united with the aim of helping the community. The men were soon joined by the Ladies Auxiliary (pictured here), which consisted of some of the most prominent women in Hamtramck. They too focused on charitable activities, such as supporting the Penrickton Nursery Home, which tended to the needs of blind children.

The Kiwanis

The Kiwanis Club was formed in 1941 as an offshoot of the old Hamtramck Exchange Club. In the beginning, 39 local businessmen gathered with the intent of forming a new social organization that would promote strong family, religious, and economic standards. For years, the Kiwanis conducted many programs in town, including sponsoring the Fourth of July fireworks at Veterans Memorial Park. In the photo, Fr. F. Hasiak and Bert Parrish present the then-new charter.

The Gray Ladies

They were called Gray Ladies because of the color of their uniforms, but they were hardly drab. The Gray Ladies came to St. Francis Hospital in 1947 and performed many services such as passing out food trays, changing bedding, bathing patients, and running errands for doctors and nurses, helping patients in myriad ways. Irene Kalinski was their first chairwoman.

Polish Falcons

The Polish Falcons were formed in 1887 in Chicago to promote physical fitness and athletics. The Hamtramck branch, Nest 86, began in April 1907, with the Ladies unit created in 1925. The Falcons' motto was: "In a healthy body—a healthy mind." The Falcons built a headquarters on Caniff Street in 1947. Its greatest moment, however, came in 1948 when Hamtramck hosted the National Convention, which brought 5,000 Falcons from across America to Hamtramck.

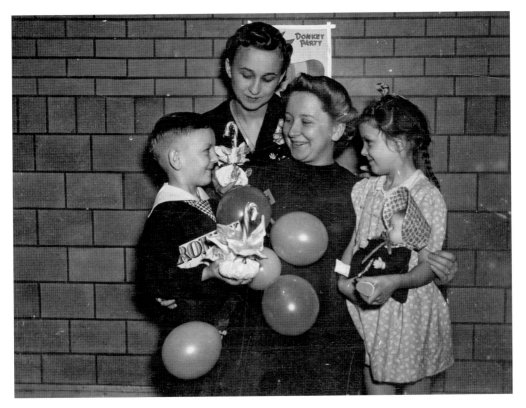

Good Study Habits

The Junior Study Club was formed in 1930 at St. Anne's Community House "to maintain an organized center to foster and develop cultural interest of its members and to equip them for leadership in and service to the community." The club held many events over 20 years, including this party with Donald Bobowski, Mrs. William Zegolewski, Mrs. Wesley Wojtowicz, and Delphine Kordas.

Activists

With Hamtramck's population becoming overwhelmingly Polish in the second decade of the 20th century, it was inevitable that Polish civic organizations would become established. The Polish American Century Club, formed in 1917, was one of the most far ranging. It took part in community programs, and unlike most such groups, played an active role in politics. Its restaurant-hall on Holbrook Avenue was a popular place for years.

Buy HEC

The Hamtramck Economic Council was formed by Mayor Albert Zak in 1959 "to keep jobs and industry in Hamtramck." It brought together civic and business leaders to promote the city's business community. Special Buy HEC Days offered bargain prices to attract shoppers. HEC served as the impetus to establish the Hamtramck Merchants Association and the Chamber of Commerce. It also was a reminder of how vital business has been to the community.

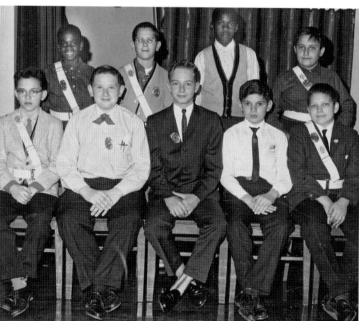

Safe Steps

Many Hamtramckans remember serving as Safety Boys or Girls when they were in school. The Safety Patrols, under the auspices of the Hamtramck Student Safety Committee, were made up of students from the city's schools. They stood at street corners around the schools, helping students cross safely. These young safety patrolers are (front row, from left) Basil Lonchyna, Daniel Zadowski, Frank Drozowski, Leonard Ptak, and Michael Hondzinski; (back row, from left) Darryl Russell, Christopher Sawa, Joe Myrick, and Joseph Bronzovich.

CHAPTER TEN

Worth Nothing

While some people made significant contributions to the community in their immediate time, they were quickly lost in the dust of history. Often, no photos of these people remain. But they should not be forgotten. They are worth remembering.

In their time, they were familiar figures in the community, particularly the early township and village administrators, some of whom still maintain a presence in town by the streets that have been named after them.

Johann George
Known but to God. We have no idea who Johann George was. His tombstone was unearthed when the GM Poletown plant was being built.

Dan Minock (LEFT)
As one of Hamtramck's most prominent early figures, Daniel Minock held a variety of posts with the village, including serving as treasurer, justice of the peace, assistant city attorney, and president of the village council. He came to Hamtramck in 1913 and entered politics, holding a host of offices through the years. He ran for office one final time in 1930 but was defeated. Thereafter he operated a law practice. He died in 1947 at age 71. Dan Street still bears his name.

Joseph Campau
Jos. Campau (it's almost always abbreviated) Avenue has been the main street in Hamtramck for nearly as long as there has been a Hamtramck. It was named after one of the most prominent businessmen who ever lived in this state. When he died at age 94 in 1863, Joseph Campau was described as "the wealthiest man in Michigan." He made a fortune in real estate and owned a huge section of early Detroit. He was responsible for encouraging early settlers to come to Detroit and Hamtramck. While rich, he was also generous, as he would forego rent from his tenants in lean times. He also increased his fortune through his involvement with the fur trade. Campau was married to Adelaide Dequindre. A Hamtramck street carries her name as well. One of Campau's houses still stands, at Jefferson and Jos. Campau Avenues in Detroit.

DeWitt C. Holbrook

Hamtramckans will instantly recognize DeWitt C. Holbrook's name. One of the city's principal streets is named after him. So was the big, old creek that ran where Holbrook Avenue now is. But he really was a Detroiter, and in 1873 was Detroit city legal counselor. He also owned a large chunk of land in Hamtramck next to Holbrook Avenue, including the site where St. Florian Church now stands.

Vern Witkowski (RIGHT)

In his everyday life, he was known as Vern Witkowski. But on Broadway he was Whit Vernon, actor extraordinare. He was a member of the Witkowski family, best known for their quality men's clothing store on Jos. Campau Avenue. But Whit Vernon had the acting bug and appeared in Broadway productions and in TV commercials.

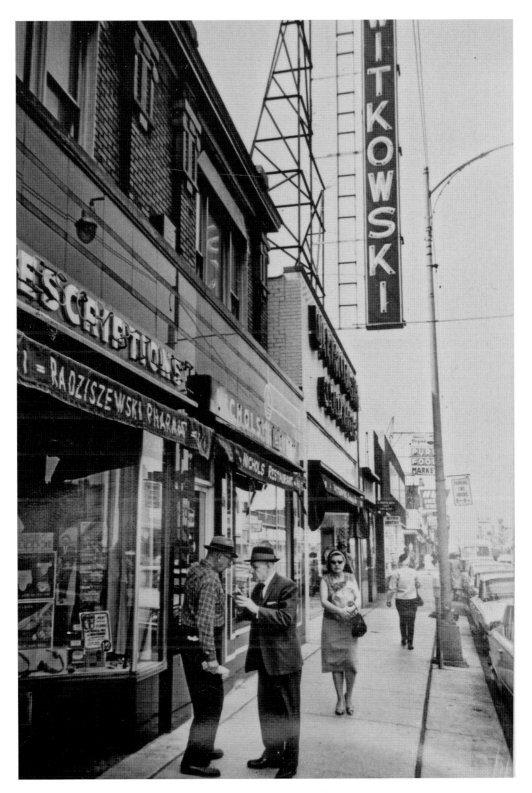

INDEX